THEN & NOW

SALEM

Opposite: Please see page 35.

THEN & NOW

SALEM

Jerome M. Curley and
Nelson L. Dionne

To my wife, Doris, and our children: Katie, Bridget, and Matthew.
You make it all worthwhile.

—Jerome M. Curley

To my father, Nelson Dionne, and grandfather Ludger Dionne,
who by sharing their stories of the Salem fire
gave me a sense and love of history.

—Nelson L. Dionne

Library of Congress control number: 2008932684

Published by Arcadia Publishing
Charleston SC, Chicago IL, Portsmouth NH, San Francisco CA

Printed in the United States of America

For all general information contact Arcadia Publishing at:
Telephone 843-853-2070
Fax 843-853-0044
E-mail sales@arcadiapublishing.com
For customer service and orders:
Toll-Free 1-888-313-2665

Visit us on the Internet at www.arcadiapublishing.com

On the front cover: Please see page 81. (Historic photograph by Leland Tilford, courtesy of the Dionne collection; contemporary image courtesy of Jerome M. Curley.)

On the back cover: Please see page 60. (Photograph by Leland Tilford, courtesy of the Dionne collection.)

CONTENTS

ACKNOWLEDGMENTS

Initial thanks are for those people who have preserved Salem's heritage in image and reality. We also want to express our heartfelt thanks to the many people and organizations that not only made the production of this book easier but also enjoyable.

We are grateful to the Salem History Society for its support. This society was instrumental in getting the authors together for this project. The society's online forum is the place to go for Salem history.

Thanks to Christine Michelini of the Peabody Essex Museum and Helen Van Tassel of Hasbro, Inc. They were very helpful in gathering information about Parker Brothers Company.

Thanks to Phil Orbanes, the president of Winning Moves, a game company in Danvers, and author of books about Parker Brothers, who shared photographs.

Linda Cappuccio of Strega Restaurant and Lounge on Lafayette Street was a great help in sharing the roof of the Strega Restaurant for the photograph of Peabody Street.

Mark Livermore of Markwood Management allowed access to a roof to re-create the post office photograph and provided a helpful escort from Salem Lock and Safe.

Thanks to attorney MaryEllen Manning for her ongoing support as well as the use of her office window overlooking Essex Street.

A special thanks to pilot Ken Gandolofo for his support and photograph flights over Salem. Real skill was needed to navigate the flight restrictions around power plants that make photography a challenge.

We would also like to thank William Pepe, author of Arcadia books on Quincy and Weymouth, for sharing his expertise on copyright matters.

Thanks to Jim McAllister of Derby Square Tours, a well-known writer and Salem historian, for taking the time to review our book and offer comments.

There would be no book without the photographic skills of Leland Tilford, the photographer for many of the vintage photographs found in this book. His skill has stood the test of time and gives us great images of an earlier Salem. The Walker Transportation collection deserves special recognition for preserving these images.

Thank you to Erin Rocha, editor at Arcadia Publishing. She has been a great help and supporter through all the phases of this book.

Thanks to our families, who have been supportive in producing this book. They were and are our first and best critics.

All vintage images are from the collections of the authors unless otherwise noted. All contemporary photographs were taken by Jerome M. Curley.

INTRODUCTION

Salem is a small city of approximately 40,000 about 16 miles northeast of Boston. It has a rich history that dates back to 1626 when a group of English colonists left the untenable fishing colony at Cape Ann. Led by Roger Conant, they moved down the coast to a fertile area known as Naumkeag and established a settlement. The few Native Americans in the area were not hostile to the settlers.

They gradually grew into a strong colony of Puritans intent on following their principles and God's law to the letter. Early on they changed the name *Naumkeag* to *Salem*, based on Psalm 70 to mean "shalom" or "peace."

Salem flourished with more settlers coming to this Puritan enclave where planting, fishing, and trapping were mainstays. By 1638, shipbuilding in Salem had started.

Into this successful settlement came the dark clouds of fear and distrust in 1692 with the witchcraft hysteria and trials. This event has had a profound effect on Salem and marked the city as the "Witch City." Over 100 people were accused of being witches or wizards. When the dust settled and clearer heads prevailed, 20 people had been executed. No matter how many apologies or reparations were made, Salem has been forever marked by this event.

As the settlement grew, more trade and shipbuilding commenced. Salem by the early 1700s was crowded with wharves and shipyards. Like the other colonies, Salem chaffed at the way London ruled the colonies, imposing restrictions and taxes.

There was regular trade between the colonies, England, and the West Indies. As the Salem fleet grew, it was aided by the opportunity presented when England was at war with its European neighbors. Salem merchant traders became privateers, and armed with letters of marque, they seized enemy ships and their cargos as spoils of war, increasing the wealth of Salem.

Leading up to the Declaration of Independence, Salem patriots early on refused to import tea and other taxed goods.

The First Provincial Congress was formed here in defiance of the British government. It was also here that the first armed resistance to British rule took place in what is known as "Leslie's retreat" almost two months before the battles at Lexington and Concord.

During the Revolutionary War, in addition to sending men to fight, Salem did what it did best: privateering. Throughout the war, Salem privateers seized hundreds of tons of British shipping.

With independence, Salem merchants turned their sights on the sea as the future and began a golden age for Salem trading. The local merchant fleet scattered across the seas in search of trade. It was first to trade with Japan and many countries of the Far East, bringing back spices, silks, and curiosities in huge quantities. Fortunes were made, and with those fortunes, mansions and public buildings sprang up throughout Salem.

At the height of East India trading, Salem had over 40 wharves throughout the city. On any day, the skyline was crowded with masts and flags of countries from around the

world. There were wharves along Front Street, at Norman Street, and along the coast as well as the North River to the present Grove Street.

Wealthy captains and merchants had elegant homes built along Chestnut and Essex Streets. They started charities, libraries, and the oldest continually operating museum in the country. Many of these buildings remain as testaments to not only their ingenuity but also the foresight of those who preserved this great heritage.

It was during this time that Salem's most famous literary figure was born. Nathaniel Hawthorne, the author of such classics as *The Scarlet Letter* and *The House of the Seven Gables*, was born in 1804. His writings have forever imparted his vision of the Puritan days and Salem on the imagination of a country.

Salem's trading days were numbered due to a variety of factors both political and natural. Salem's trade shifted from goods to coal to fuel the growing factories and mills as manufacturing took hold in Essex County. In areas where there had been shipyards and ropewalks, suddenly there were leather factories and mills.

Salem became a hub for manufacturing in the mid- to late 1800s with such industries as the Naumkeag Steam Cotton Company as well as numerous tanneries and factories. Immigrants from around the world were drawn to work in Salem.

With its jobs, large shopping district, and amusements, Salem continued to be a vital center of commerce for the region. This growth was marred by a devastating fire in 1914 that destroyed approximately 1,376 buildings on 253 acres in a swath across the city.

While much history was lost, much was also spared, leaving Salem with an intact architectural history to cherish. Salem rebuilt almost immediately with some fine examples of early-20th-century architecture that are included in this book.

As time progressed, more expansion occurred, wharves were removed, and rivers were channeled into canals or filled in, adding land for expansion.

Salem undertook major redesigns such as the depot removal and railroad crossing improvements in the 20th century. Those time-consuming and disruptive moves took their toll on downtown businesses. When the construction was done, it was only a little while before shopping malls appeared. One very close to Salem opened in 1958. This marked the beginnings of a low point for Salem as stores moved to malls; the Naumkeag Mill closed in 1954 in search of cheaper labor. Salem found itself in the 1960s and 1970s a victim of corporate mergers with older industries being acquired by foreign companies and closing or moving.

In this era of decline and self-examination, Salem began to market itself as a tourist attraction. Rather than downplaying the witch history, it was embraced, drawing thousands to the city each October for Haunted Happenings. This has spawned a cottage industry of witchcraft shops, psychic readings, and specialty museums in the city.

As time has moved forward, Salem has sought a balance by encouraging examination of its truly historic character, its many architectural treasures, and its maritime and literary history. These efforts have been greatly aided by the merger of the Peabody Museum with the Essex Institute, resulting in a major expansion of this world-class museum. This tourism focus that draws over a million people a year has resulted in a renewed interest in Salem's history beyond the witchcraft focus, hopefully making for better preservation efforts to cherish a shared past as residents move toward Salem's approaching 400th anniversary.

The majority of this book's images come from the early 20th century, the time of more accessible photography. Salem was still a manufacturing center as well as a shopping destination, as many will recall. By pairing older images with the recent, readers can see change that has occurred.

Salem from the start of the 20th century up to the 1950s went through many changes that some will recall vividly. For those too young to recall the train depot and the Almy, Bigelow and Washburn Department Store, they will see glimpses of an older Salem that has adapted to circumstances while remaining a vibrant, welcoming city.

ALONG WASHINGTON STREET

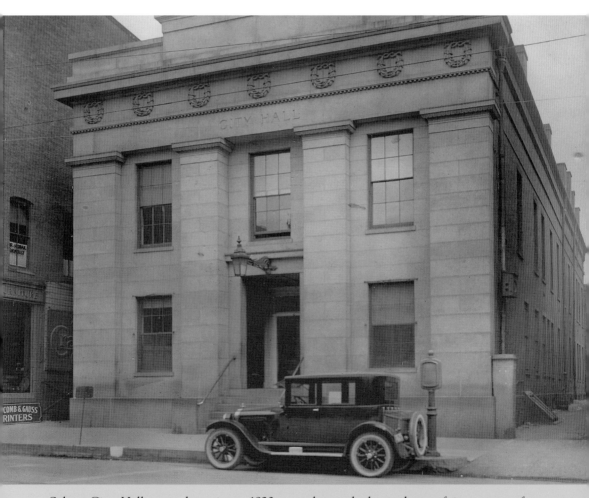

Salem City Hall, seen here in a 1920s photograph, at 93 Washington Street, was built in 1837 and designed in the Georgian Revival style by Richard Bond. The gold eagle perched on the roof is a copy of the Samuel McIntire carving from the Washington Square gate that was on Salem Common for many years before its removal.

The Salem Depot was built in 1847. With its imposing size, it dominated downtown until it was torn down in 1954. Even though it was architecturally worthwhile, most residents who remember it recall its odorous interior. A parking plaza replaced it when the depot was relocated to the entrance of the new tunnel that rerouted the train beneath downtown. In the 1980s, the station was again moved to the other end of the tunnel on Bridge Street.

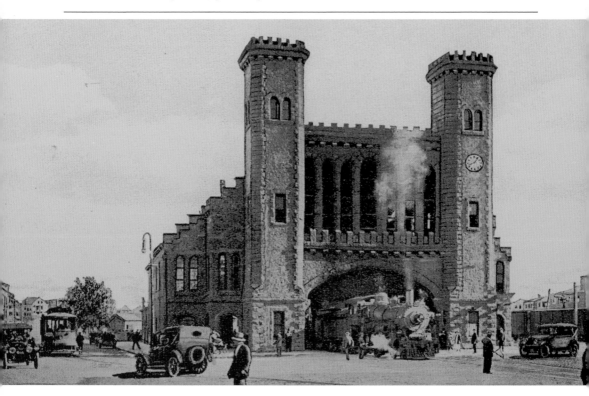

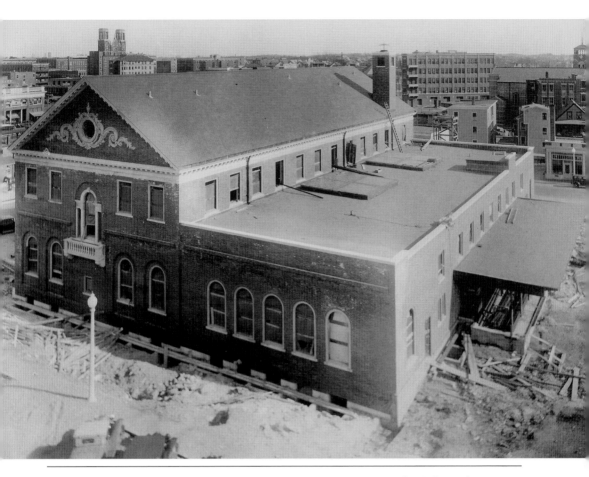

Listed on the National Register of Historic Places, the Salem Post Office is seen being built in 1933. When Philip Horton Smith designed this building, he used the Colonial Revival style, which fit well with the architecture of Salem. This was a major construction for Salem where some 50 businesses and homes were removed for this block-size building. Noteworthy in the photograph is the Salem Flatiron Building on the right of the chimney. This was removed with the Riley Plaza construction.

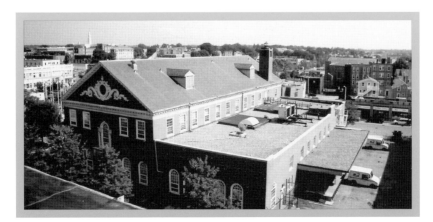

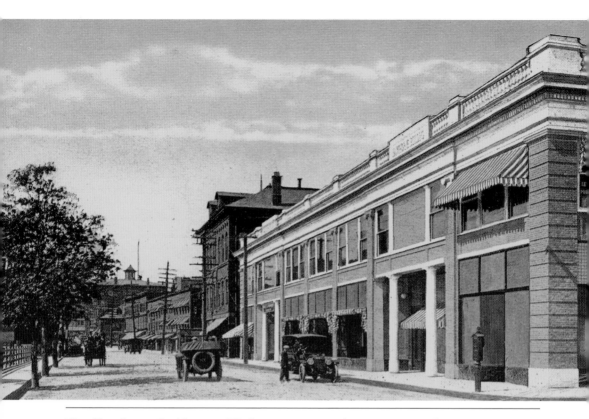

The Hawthorne Building on Washington Street at the beginning of the 20th century was home to Ropes Pharmacy. Washington Street was divided by the depressed railroad, which was later enclosed in a tunnel. With the removal of the Salem Depot and the tunnel extension, Washington Street was widened. When New Derby Street was laid out in 1913, the Flint Building beside it was removed. For many years, Eaton's Apothecary dominated the building, which is now a bank and stores.

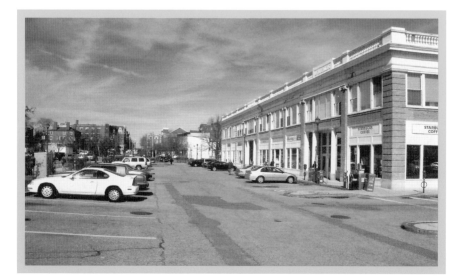

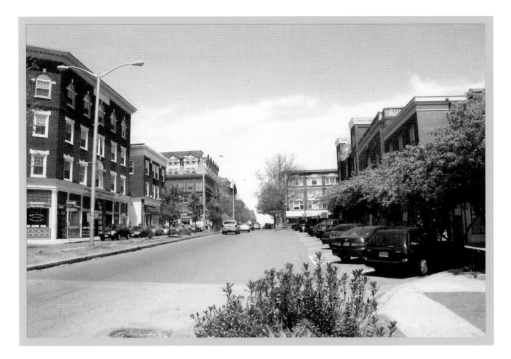

Washington Street looking toward Town House Square was very different at the start of the 20th century. It was divided by the railroad tunnel that ran from the depot. The oldest street in Salem, it was here that the South and North Rivers connected. They were filled in when building the train depot. At the time of this photograph, the Joshua Ward House, a Federal mansion at No. 148, was behind a commercial building. It has since been restored.

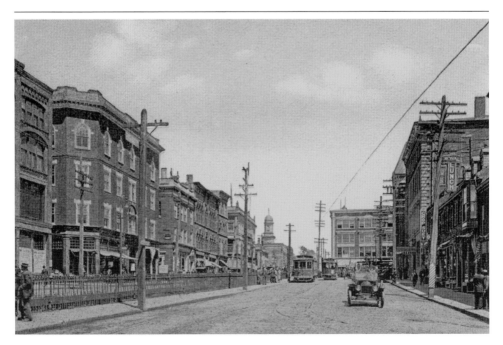

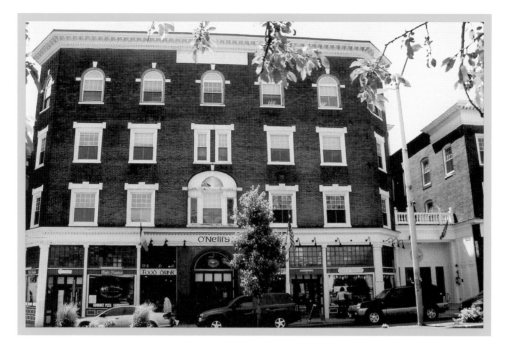

Known as the Peabody Block when built in 1891, this building started out as mixed use with stores and offices. The two upper levels housed the Salem Commercial School, which had a great reputation for training clerks and secretaries. The lower floors had offices for the Pickering Coal Company and the *Salem News*. The building now houses two popular restaurants and an Irish pub. The top floors are used as municipal offices by the city.

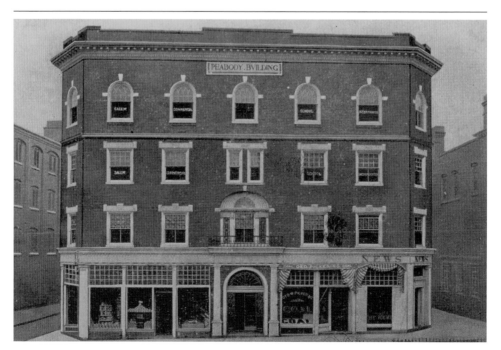

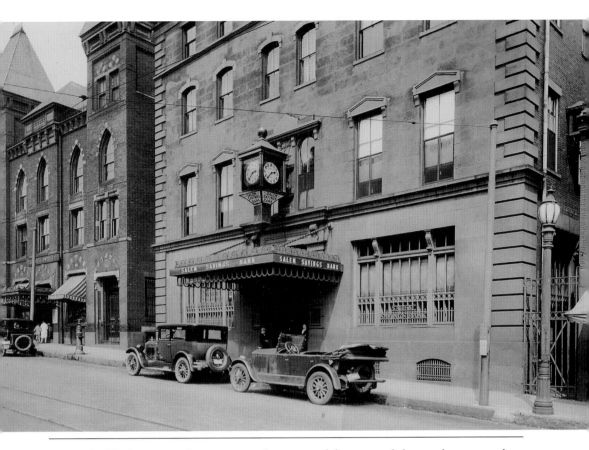

At 125 Washington Street was the Salem Savings Bank in the early 1920s. This building was originally the Asiatic Building, built in 1855. When built, it was four stories, and when remodeled as a bank in 1910, two stories were removed. Later remodeling moved the overhang next door to Daniel Low's building for an additional entrance to this popular jewelry store. Low's building was originally the site of the First Church, the first regularly organized church in America in 1629.

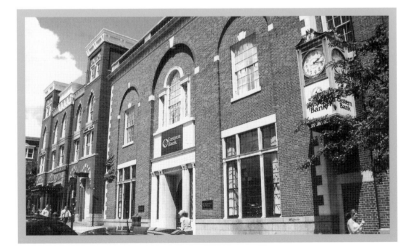

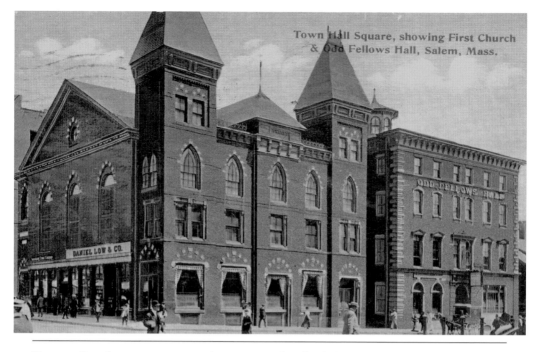

Town Hall Square, showing First Church & Odd Fellows Hall, Salem, Mass.

During Revolutionary times, the town house stood nearby. Here colonists protested tea taxes. The last general assembly of the Province of Massachusetts Bay met in June 1774. In defiance of Gov. Thomas Gage, they chose delegates to the First Continental Congress. The governor dissolved the group, which met anyway in October, with John Hancock presiding, and formed the First Provincial Congress that adjourned to Concord. Daniel Low's building was built as the First Church in 1826 and extensively remodeled in 1874.

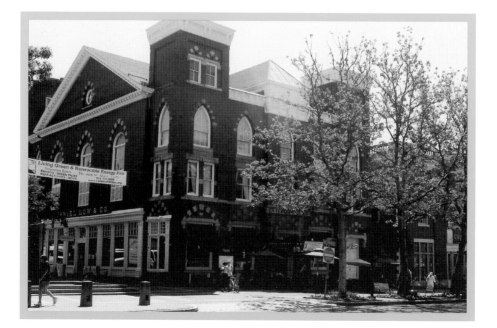

The Elco Lunch and Schulte Smoke Shop on the corner of Essex and Washington Streets are shown in 1933. Note the NRA signs in the windows referring to 1933 National Recovery Administration. Note also the sidewalk elevator used for deliveries. This building burned down in the 1960s. This corner lot was dedicated as Lappin Park in 1993. In 2005, the statue of Elizabeth Montgomery, the television star of the *Bewitched* series, was added and has become a popular tourist attraction.

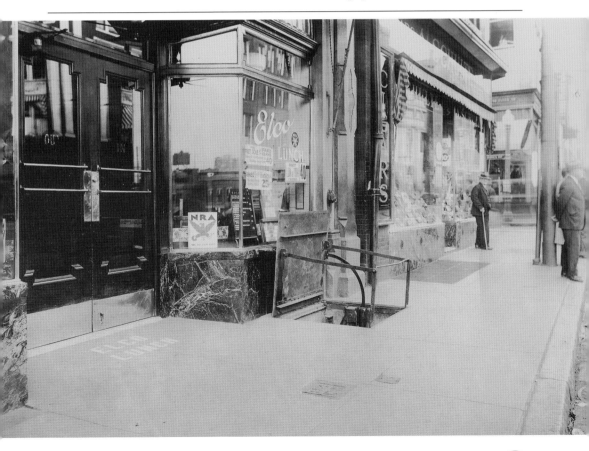

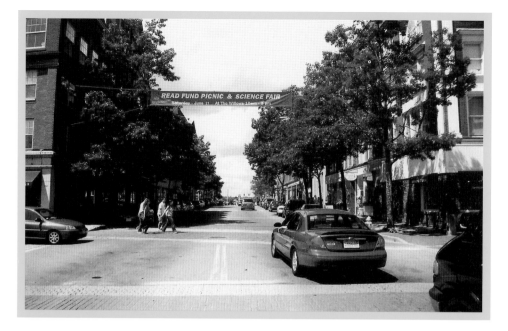

This is a view of Washington Street just up from Town House Square. Washington Street, laid out in 1626 based on a Native American path, was called School House Lane, then later Town House Lane, and later still Washington Street. This was a busy intersection where people were directed by a police officer in an era before traffic lights. The traffic box was hit by drivers late at night on a frequent basis. Note the many businesses on the street.

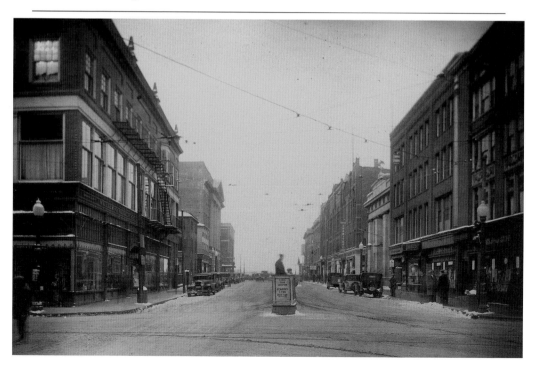

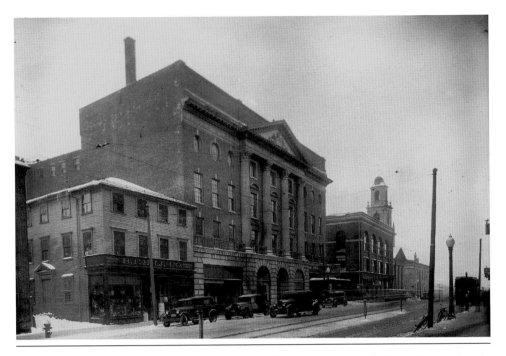

This landmark building is one of the largest Masonic temples in Massachusetts. Built in 1915 on the site of the Derby mansion, it accommodated not only the Masonic lodge with a banquet hall and library but also retail space and professional offices. Its massive Colonial Revival style highlighted by the four fluted columns makes this building very distinctive. It now houses retail stores on the ground floor while most of the building is rented as professional offices.

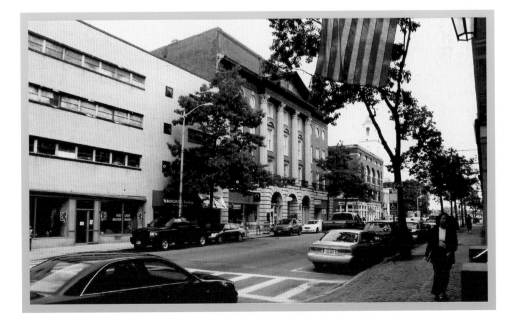

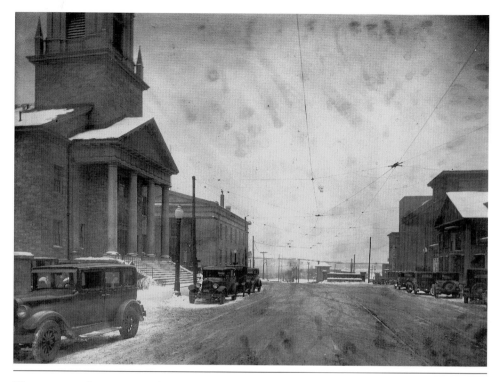

This view of upper Washington Street shows the recently built (1923) Tabernacle Church on the left. This is the third church on this site since 1776. The tower is very similar to the one Samuel McIntire added to the first church standing here in 1805. Also noteworthy in the photograph is the raised platform at the end of the street. This marks the end of the Salem train tunnel and is where trains emerged on their journeys north.

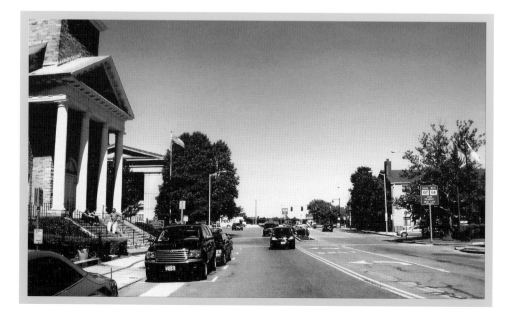

The Federal Theater, built by the Koen brothers in 1913, housed vaudeville shows then movies and was known for one of the largest Wurlitzer organs on the East Coast. In 1937, the building was converted into the largest A&P grocery store on the North Shore, complete with a bowling alley in the basement. After years of little use, it succumbed to urban renewal in the 1970s and was replaced by a large condominium development. (Historic photograph courtesy of the Koen collection.)

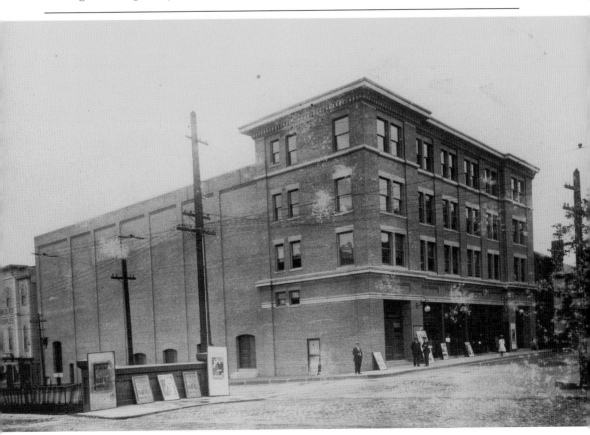

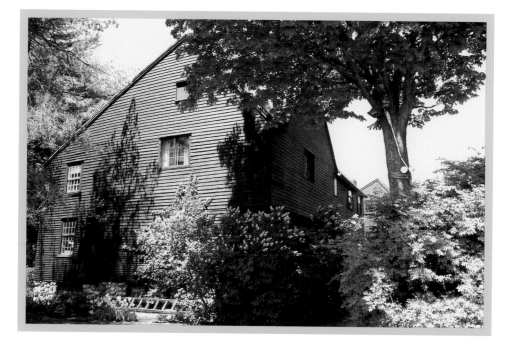

The Hooper-Hathaway House, also known as the "Old Bakery," sat for many years on Washington Street near Federal Street. In 1911, when the house was to be razed, Carol Emmerton, a local philanthropist who was in the process of restoring the House of the Seven Gables, rescued the house and had it moved to the grounds of the House of the Seven Gables, where it was restored. The house was built in 1682 and is a prime example of early Salem.

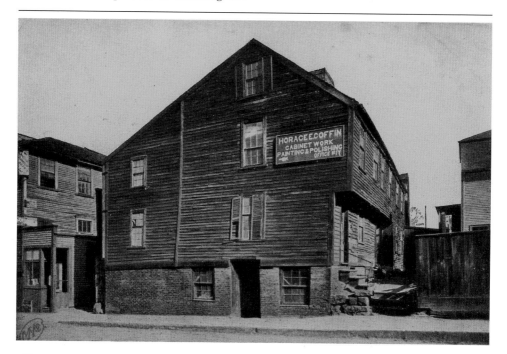

ALONG ESSEX STREET

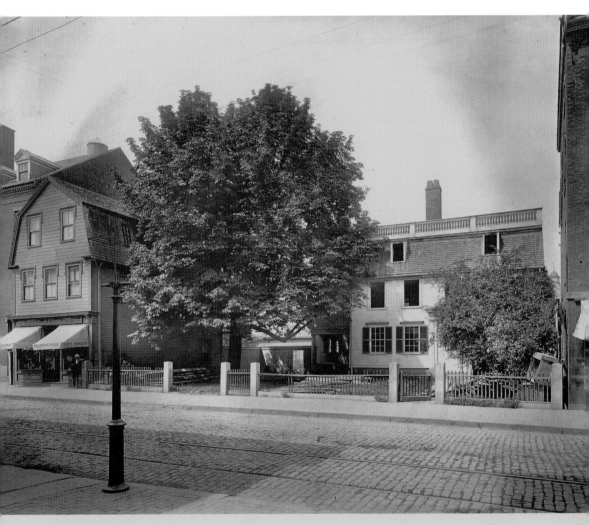

The Sanders home is shown before 1898, when it was torn down to build the YMCA. From 1873 to 1876, Alexander Graham Bell lived here and gave speech lessons to Mary Ann Sanders's deaf grandson. Here Bell worked on his invention of the telephone. He later demonstrated the first distance telephone to Boston from the Salem Lyceum on February 12, 1877.

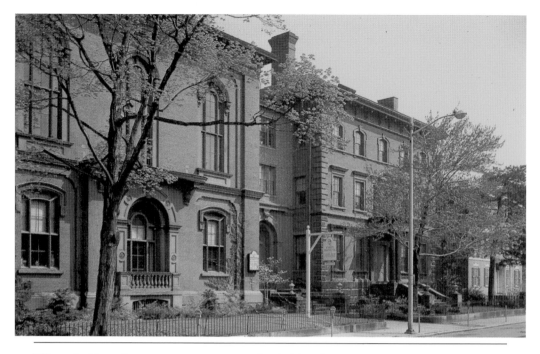

When the Essex Institute was incorporated in 1848, its three functions were to support a historical museum, provide lectures and discussions, and issue publications. In succeeding, the institute has developed a reputation as one of the premier institutes in the country. These historic buildings hold collections of early deeds and treaties as well as witchcraft trial memorabilia and ship logs from the East India trade. The Essex Institute merged in 1992 with the Peabody Museum to form the Peabody Essex Museum.

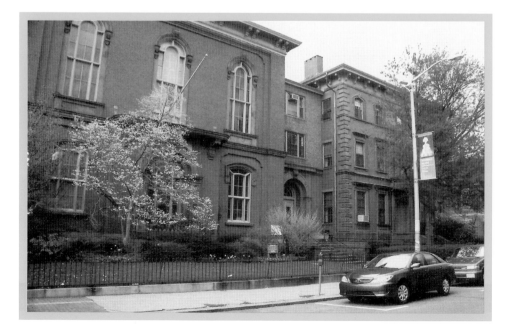

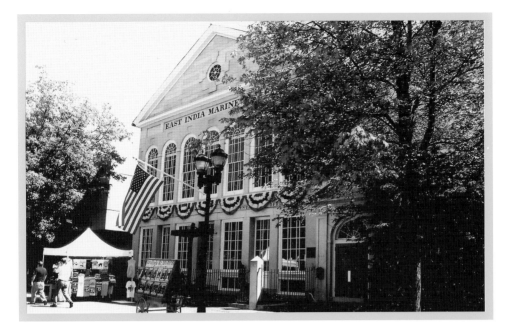

East India Marine Hall was opened in 1825 to house the collections of the East India Marine Society that was formed in 1799 with membership limited to ships captains and supercargoes who had sailed around either the Cape of Good Hope or Cape Horn. Its purpose was sharing navigation information, assisting disabled sailors and their families, and sharing curiosities collected on distant voyages. From these beginnings grew the Peabody Essex Museum, the oldest continually operating museum in the United States.

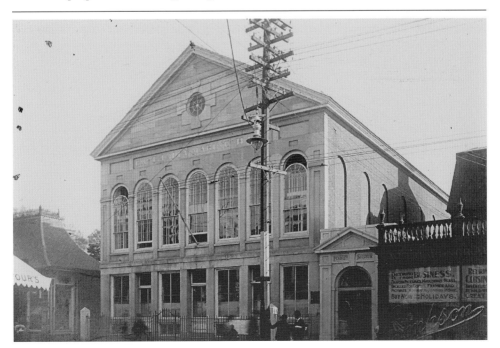

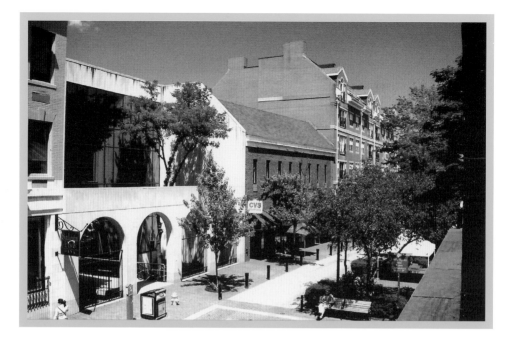

Many will recognize Essex Street from the early 1950s since the street remained similar well into the 1960s. While Salem's population was approximately 40,000 in the 1930s and 1940s, the shopping district attracted almost 200,000 shoppers yearly, drawn by large department stores, businesses, and theaters. With the advent of shopping centers, the area fell into decline until the 1970s resurgence with a tourism focus. This pedestrian street now has shops, restaurants, and a greatly expanded Peabody Essex Museum drawing significant numbers.

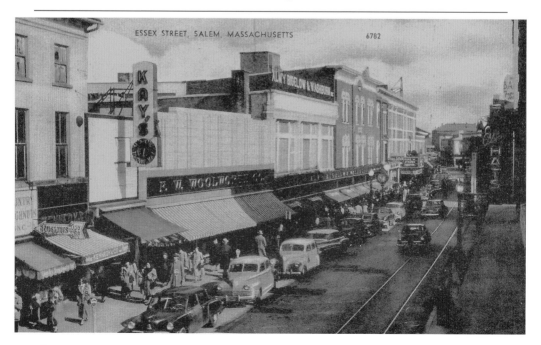

ESSEX STREET, SALEM, MASSACHUSETTS 6782

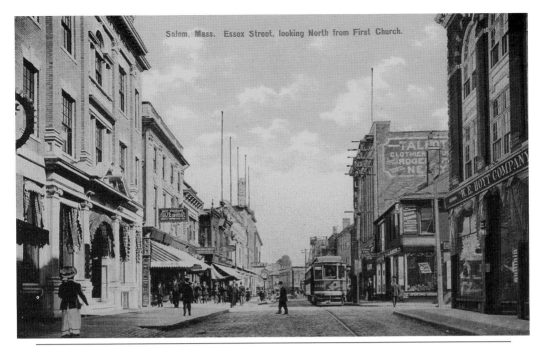

Essex Street was a bustling thoroughfare of banks, stores, and theaters. In the late 1970s, the street became a pedestrian way. The Naumkeag Trust building that housed a bank has been converted into a church for the Gathering with offices upstairs. Up the street with flagpoles above stood the large department store Almy, Bigelow and Washburn, which drew people from throughout the North Shore. Farther down the street was the large Paramount Theater

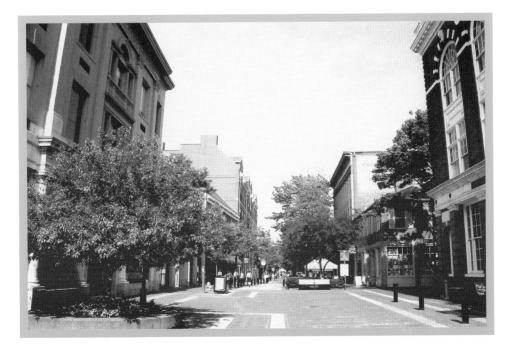

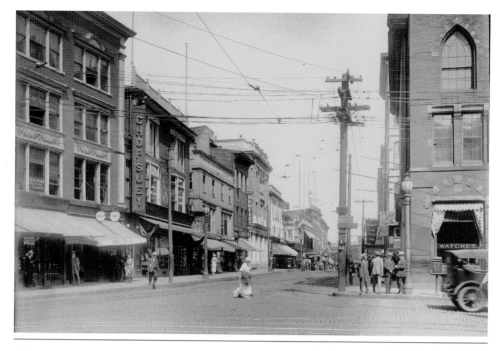

This distinctive view shows Essex and Washington Streets. Essex Street has been the heart of Salem's shopping district since Puritan days. Near the intersection of Washington Street was the town pump written about by Salem author Nathaniel Hawthorne in "A Rill from the Town Pump," included in *Twice Told Tales*. With urban renewal this became a pedestrian walkway, and a memorial fountain on the left was added. The street remains a busy shopping street now with small shops and restaurants.

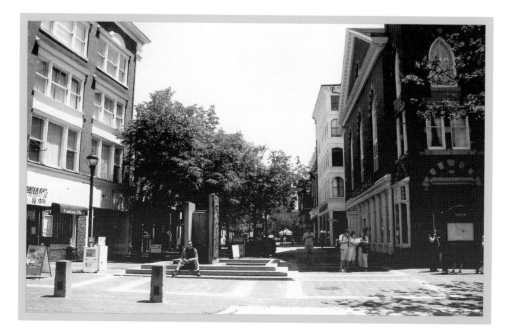

Town House Square at the corner of Washington and Essex Streets was a gathering area in Salem from its beginning. The first permanent shelters built were along what is now Essex Street. The town pump was in the square. The pump was removed with the construction of the railroad tunnel. The platform depicted covered the tunnel and served as a civic plaza. When there were charitable drives, signs were often placed here to mark the progress of donations.

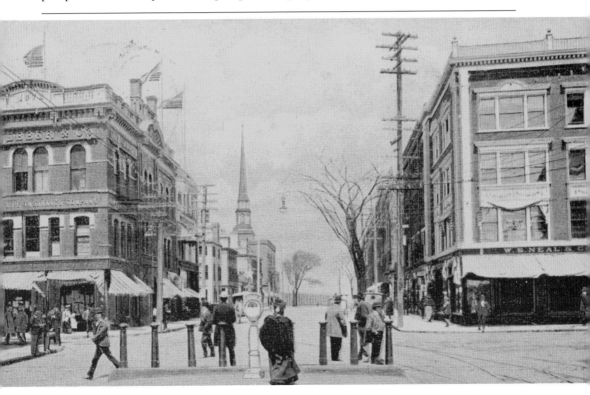

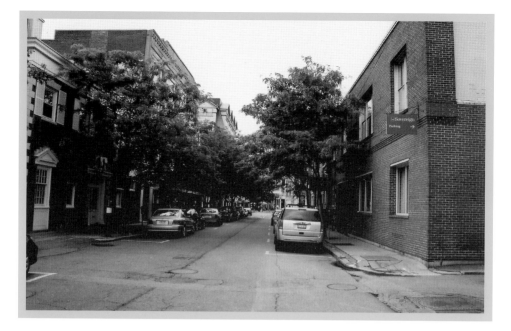

Essex Street, at Barton Square, looking toward Washington Street in the early 20th century, was a busy shopping area with vaudeville and movie theaters. The Salem Theatre opened in 1901 and operated until the 1930s. Most buildings have been removed or renovated into apartments and condominiums. The street level still retains some shops, a bank, and a restaurant. On this end of the street was the home of Capt. Jonathan Haradan, commander of the frigate *Salem* during the Revolutionary War.

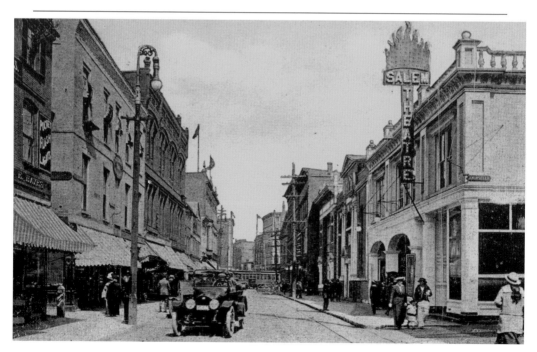

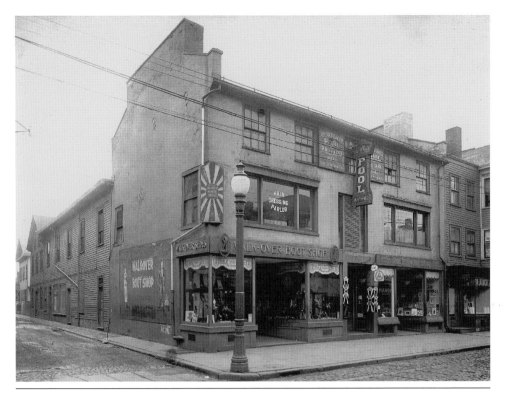

No. 265 Essex Street, known as the Frye Building, was built in 1763. In the early 20th century, several stores shared this block. The Social Hour Pool and Billiard Hall had seven tables on the top floor, while the second floor was occupied by Jacques' Barber Shop and Hair Dressing Parlor. The street level had the Walk-Over Boot Shop and Rolfe's Music Store. The building now houses the Salem Chamber of Commerce.

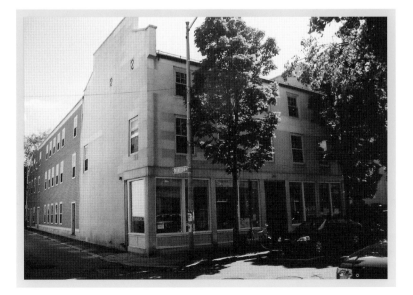

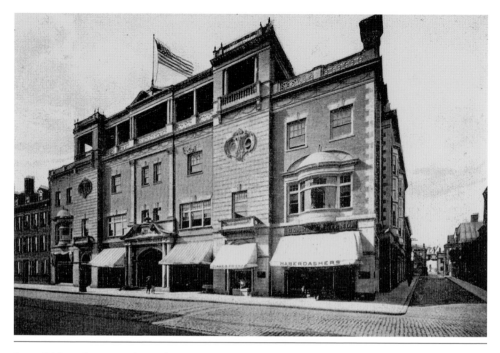

In 1898, the Sanders house where Alexander Graham Bell lived and worked on his invention of the telephone was razed to make way for a new YMCA building. The YMCA was built in the classical revival style and featured an open-air loggia on the roof. This was used for several decades for gatherings and as an observation platform for parades along Essex Street. The building was listed on the National Register of Historic Places in 1983.

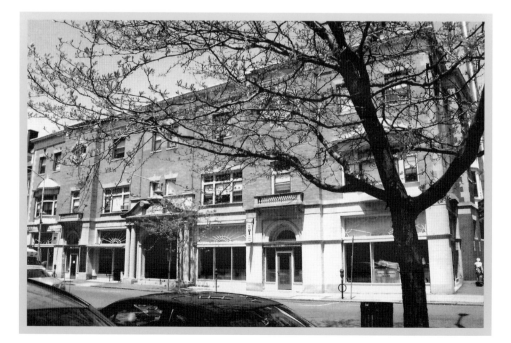

This view shows one of Salem's lost treasures. The Empire Theatre started as a vaudeville venue but was also used for movies. The movie *Shore Leave* on the marquee came out in 1925. Also noteworthy are the advertisements for vaudeville at the Federal Theater. Both theaters were owned by the Koen brothers. The Empire was located on Essex Street and had a capacity of 900 people. This was demolished in the late 1950s with the site being a parking lot since.

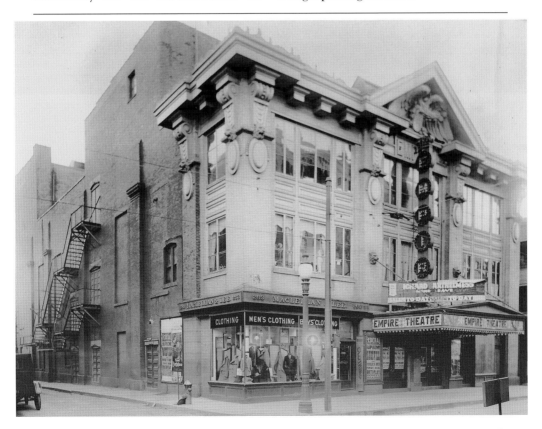

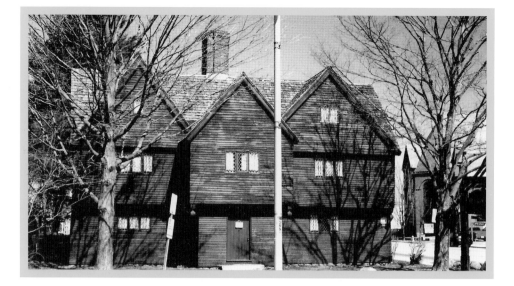

The "Witch House" is considered the oldest house in Salem. In 1675, the house became the home of Judge Jonathan Corwin, who conducted preliminary hearings of accused witches here in 1692. This association resulted in it being called the Witch House. Over the years, the house underwent changes, including the addition of a drugstore as shown. In 1944, with its destruction looming, citizens raised money and restored it to its original state. It has been a museum since 1948.

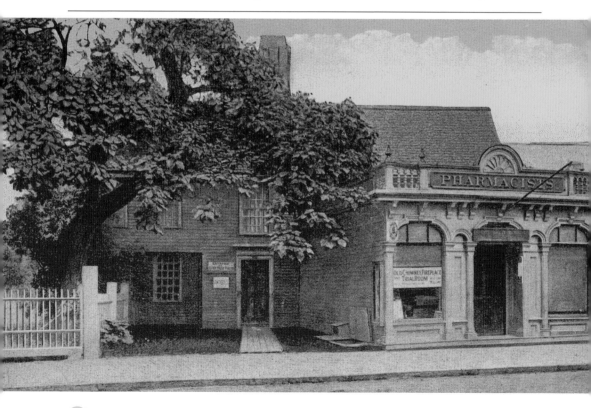

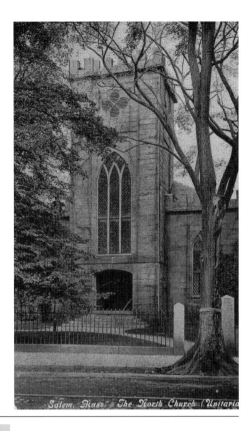

In 1772, in response to an argument over who would lead the congregation, the North Church separated from the First Church and built a meetinghouse on this site. The present church, the Second Meetinghouse, was built in 1836. It is of early English Gothic design using Quincy granite. The First Church reunited in 1923 and later merged with the Second Church in 1956. Noteworthy features are the 1891 Tiffany stained-glass windows and historic organ.

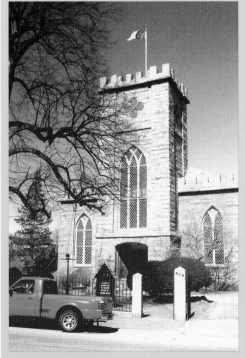

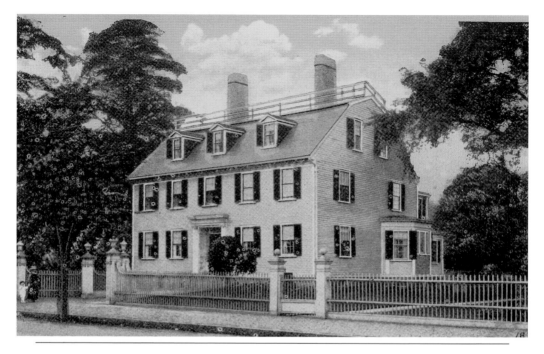

The Ropes Mansion, a Georgian Colonial, was built in the 1720s. Judge Nathaniel Ropes later bought it in 1768. Ropes, a supporter of the king in the days before the American Revolution, died shortly after an angry mob of patriots broke his windows and door in 1774. The home remained in the Ropes family until 1907, when it was bequeathed to the Ropes Memorial trustees. It has extensive gardens and is operated by the Peabody Essex Museum.

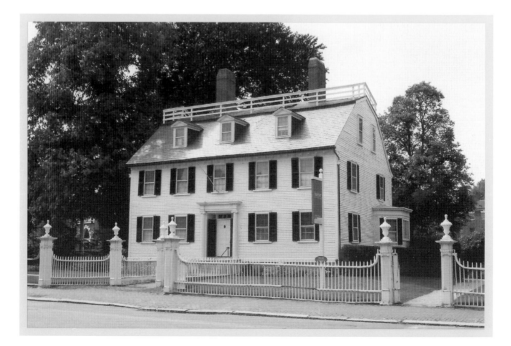

AROUND THE CITY

Salem Common was used for militia training as early as 1637, marking the beginning of the National Guard. In 1801, Elias Derby, a colonel in the militia, raised $2,500 to landscape the common for better use by the militia. Having been graded, fenced, and gated, the common was designated as Washington Square in 1802.

Before the current post office was built in 1933, Norman Street had a number of buildings leading to the old train depot. The St. Charles Tavern, a popular saloon, was on the corner of Washington Street. People still recall the train depot nostalgically. This photograph captures not only that building but the buildings removed by the post office construction when some 50 businesses and houses were demolished to make way for it.

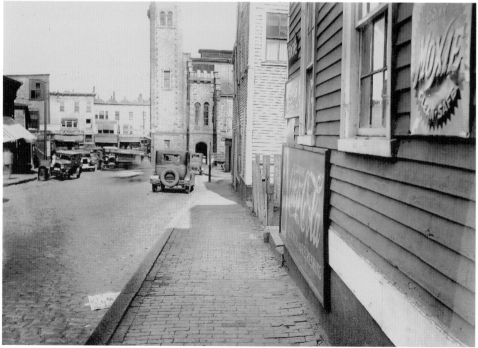

This style of strip mall building was a popular design in Salem in the 1920s and 1930s. The pictured building appears to be on St. Peter Street as it crosses Church Street. With the demolition of the Paramount Theater and the Almy, Bigelow and Washburn Department Store for the construction of the East India Mall and parking garage, this area was totally redesigned. The area where the building was is now the mall entrance to the Salem Cinema.

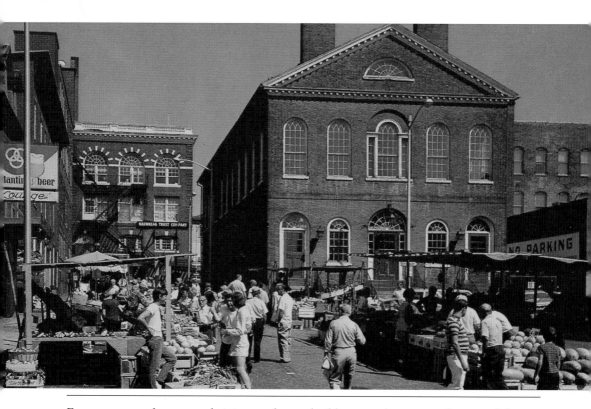

For many years, there was a thriving outdoor market for fresh produce, here shown in Derby Square. The old town hall/market was built in 1815. The market gradually faded out in the 1960s and 1970s with the increased reliance on grocery stores. This building now houses art shows and theater productions, the most notable being *Cry Innocent*, a re-creation of the Salem Witch Trials. The current space leads to Artist Row, where art galleries and restaurants draw many appreciative patrons.

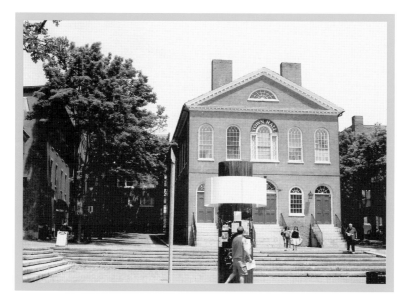

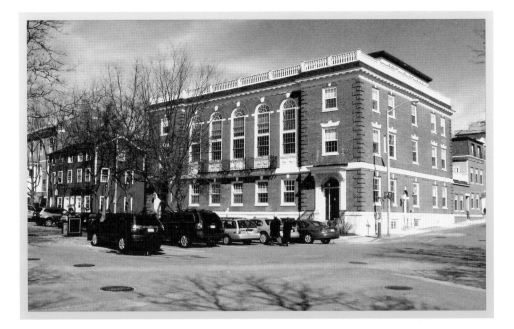

The 1913 Salem Police Department station, pictured in this 1920s postcard, is no longer in use. In 2000, it was renovated as condominiums. The monument to the Very Reverend Theobold Matthew, apostle of temperance, was moved to Hawthorne Boulevard in 1916. On the left, the grocery store is now Red's Sandwich Shop. During Revolutionary times, it was the London Coffee House, a patriot gathering place. The new Salem Police Department headquarters, built in 1992, sits off the downtown area.

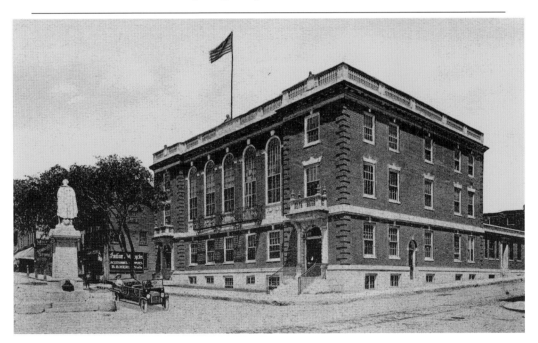

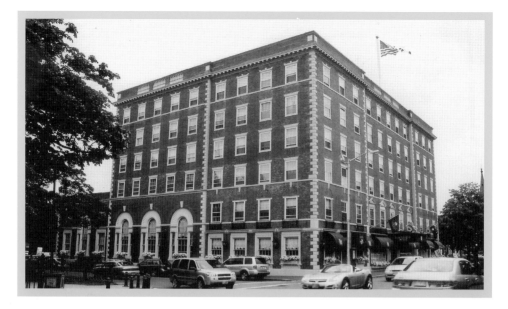

The Hawthorne Hotel was built in 1925 through public subscription. One condition for this drive was that the hotel agree to provide a meeting place for the Salem Marine Society, founded in 1766. The society had been meeting in the Franklin Building, razed to build the Hawthorne Hotel, continuously since the 1830s. There is a room—a replica of the captain's cabin of the 145-foot Salem-built bark *Taria Topan*—on the roof where the society continues to meet.

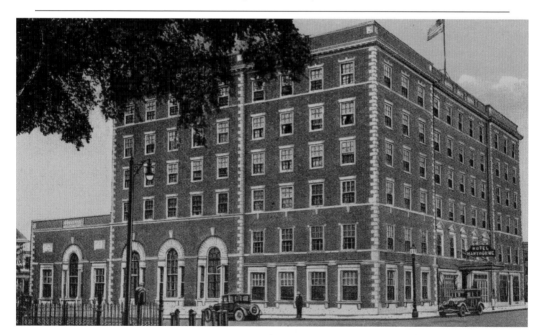

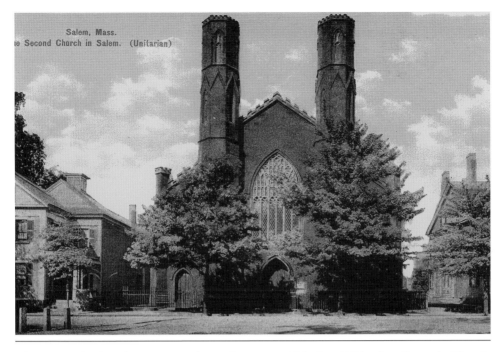

Salem, Mass.
ie Second Church in Salem. (Unitarian)

The Second Church was a product of a rift within the First Church in 1719 over leadership of the parish. The East Church was formed and built this church in 1846. A merger in 1899 formed the Second Church. The high towers were cut down in 1925. In 1956, the Second Church reunited with the First Church, and this building was sold. The interior was rebuilt after a fire in 1969. In 1972, it opened as the Salem Witch Museum.

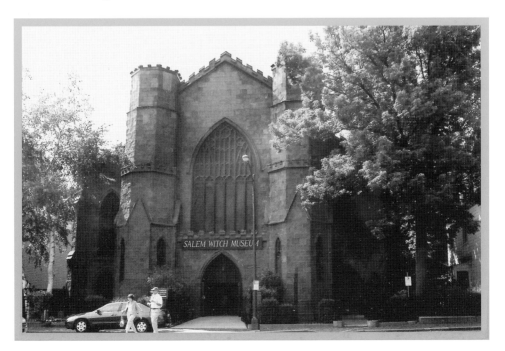

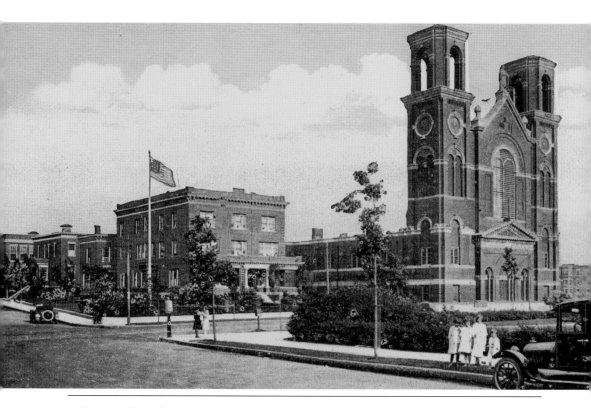

St Joseph's Church on Lafayette Street was a French national parish built by French Canadians who migrated to Salem for work in manufacturing. The parish opened in the late 19th century. The church burned in the Salem fire of 1914. When the rubble was cleared, all that remained were the towers and basement, which was roofed over and functioned as the church until 1948, when the new church was built. This church closed in 2004. Development is planned.

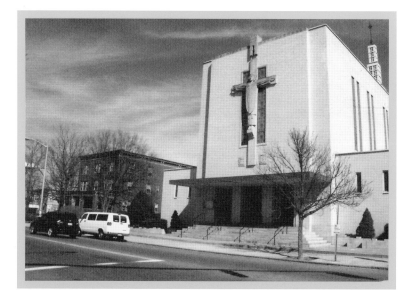

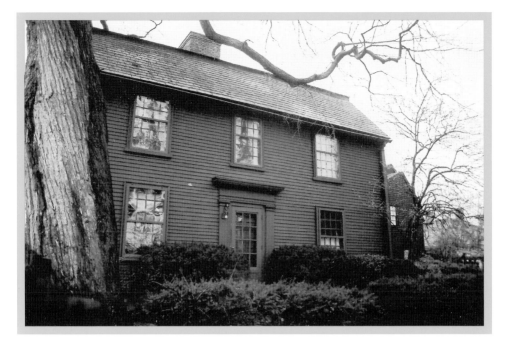

Nathaniel Hawthorne, the famous author, was born in this house on Union Street. This house was built in 1750. In 1958, the house was moved to the grounds of the House of the Seven Gables where it is seen restored. Hawthorne's father died at sea from yellow fever when Hawthorne was five years old. Due to their reduced circumstances, his family—mother and three sisters—moved in with his mother's family, the Mannings, one street over at 10½ Hebert Street.

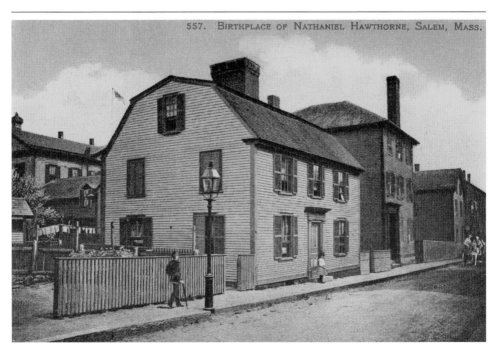

557. BIRTHPLACE OF NATHANIEL HAWTHORNE, SALEM, MASS.

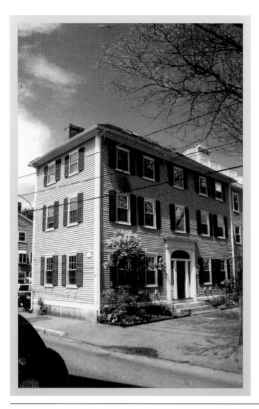

Nathaniel Hawthorne and his family moved into this house in September 1847 after his appointment as surveyor of the customhouse in 1846. It was in his quiet study on the third floor front room that he wrote *The Scarlet Letter*, a masterpiece of American literature, and prepared *The Snow Image*. Mall Street borders Washington Square where the reticent Hawthorne would often take solitary walks at night to avoid encountering people. Apart from an addition, the home is little changed.

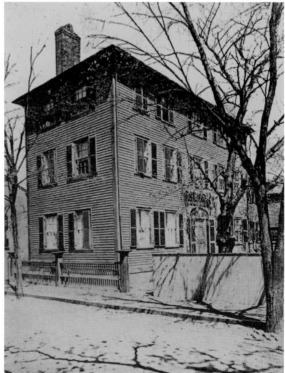

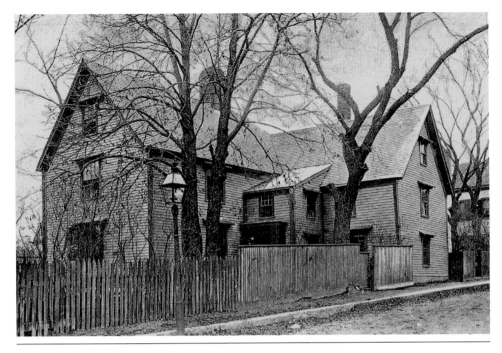

The Turner House, built for Capt. John Turner in 1668, went through many changes over the generations. Additions and gables were added and removed. Its enduring fame came when it was considered to be the setting for Nathaniel Hawthorne's famous book *The House of the Seven Gables*. In 1908, the house was purchased, restored, and opened as a museum to support the House of the Seven Gables Settlement Association, a social service agency founded by philanthropist Caroline Emmerton.

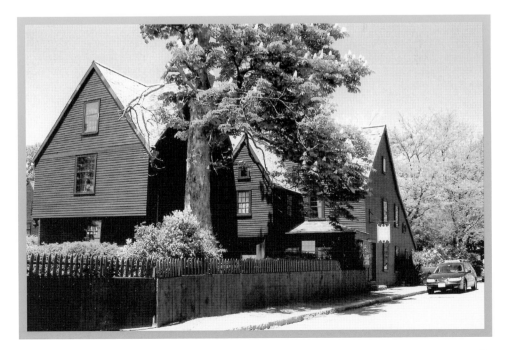

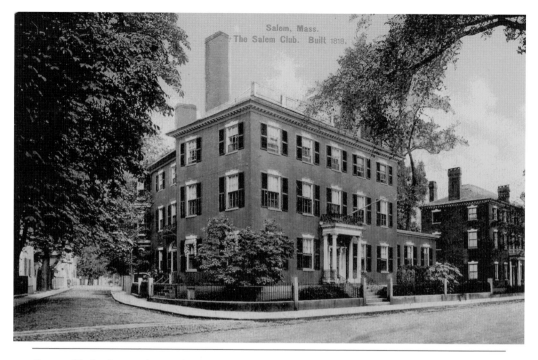

Originally built as a home for Capt. John Forrester in 1818, this house was later owned by the merchant George Peabody, who lived there for many years. In the late 19th and early 20th centuries, the building was home to the Salem Club, a male-only club that offered its members card and billiards rooms, dining rooms, a library, and sleeping rooms. In 1927, it was sold and converted to the Bertram Home for Aged Men, now known as Bertram House.

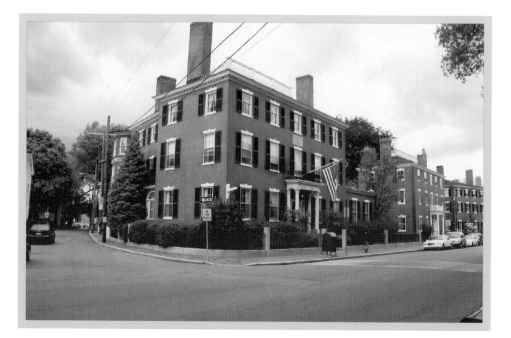

AROUND THE CITY

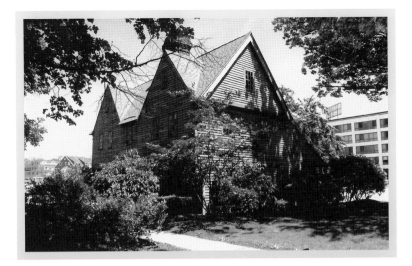

Pequot House on the grounds of the Naumkeag Mill was built in 1930 for the Massachusetts tercentenary celebration. The building, designed by Philip Horton Smith, drew on features found in Colonial homes from the 17th century. It is most akin to the 17th-century John Ward House, which is on the grounds of the Essex Institute. It was used as a USO-style canteen for servicemen during World War II. Currently it is used for administrative offices.

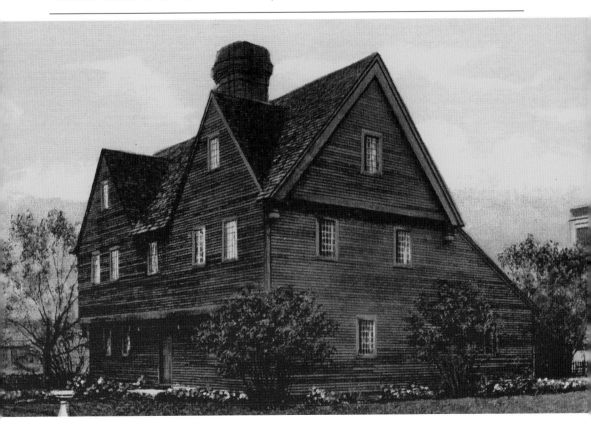

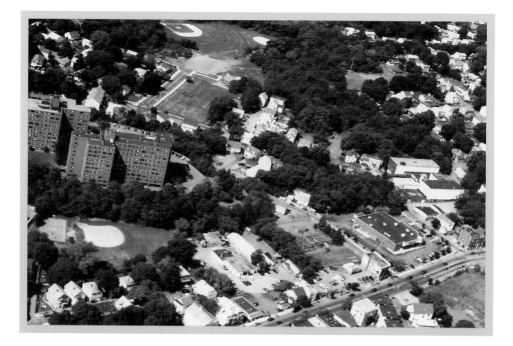

Gallows Hill, where the accused witches were executed, is an area of much conjecture. The original site was described as a hilly area on the outskirts of downtown. Most scholars conclude that the area is off Boston Street, which would correspond to the current Pope Street. This area has been developed. Farther up the street is the Gallows Hill Park. The aerial view shows the possible execution sites extending from the apartment buildings to the park and playing fields.

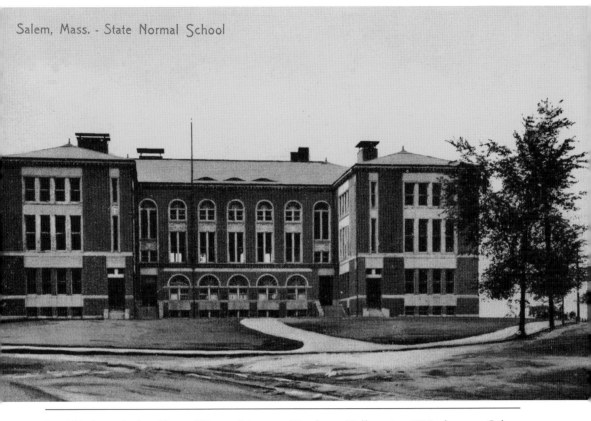

In 1854, through the efforts of Horace Mann, Nathaniel Hawthorne's brother-in-law, the state approved a normal school for Salem. It offered a two-year program for women. In 1921, a four-year degree program was started. The name changed to Salem Teachers College in 1932 then to Salem State College in 1960. This building was constructed in 1896 when the school moved from 1 Broad Street to Lafayette Street, where it has evolved from one building into today's sprawling campus.

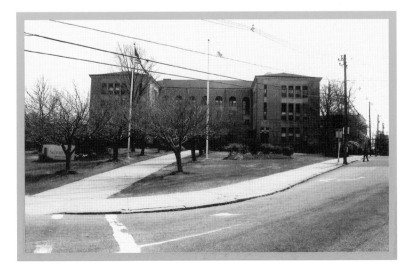

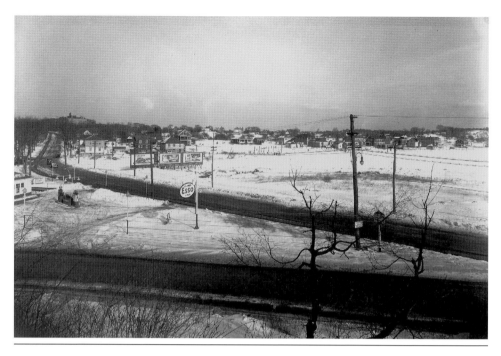

This early-20th-century view of the intersection of Canal Street and Loring Avenue shows a single building, Salem Normal School, in the distance with a gas station in the foreground. Since then the normal school, now Salem State College, has expanded greatly so that now there are the Salem State College Bertolon School of Business and other buildings. A few businesses, such as the Loring Liquors Store and the Salem Diner, remain close to this rapidly expanding campus.

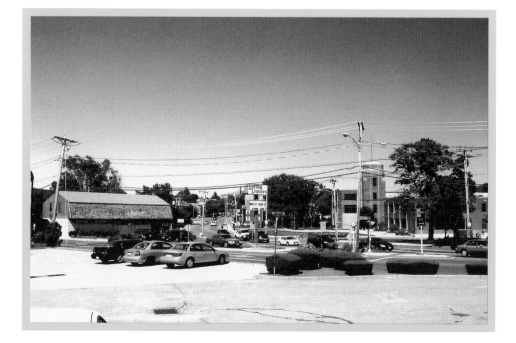

ALONG THE COAST

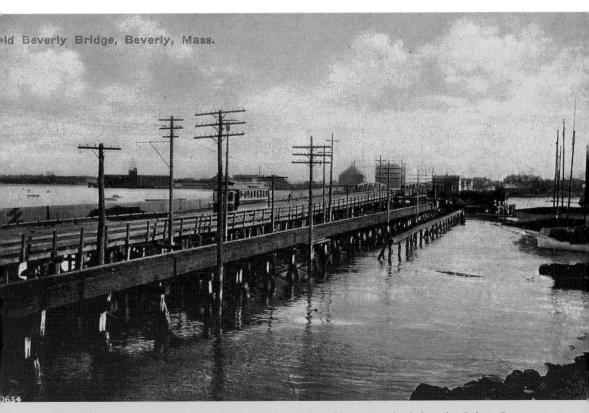

Old Beverly Bridge, Beverly, Mass.

This view of the Essex Bridge looking toward Salem shows a streetcar crossing. In more recent times, there was a secondary railroad bridge built on the Newburyport Railroad line. On the left is the Salem Gas Works with its large expansion tank that would rise and fall depending on supply.

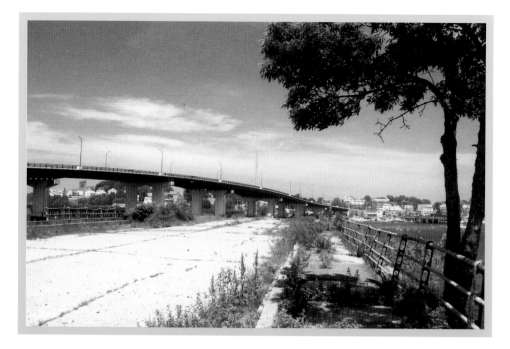

The Essex Bridge is now called the Veteran's Memorial Bridge. In Salem's earliest days, there was a ferry to transport people across the Danvers River to Cape Ann. Over the years, there have been a number of drawbridges that connected the two cities. The first drawbridge was built in 1778 and inspected by George Washington in 1789. This was very busy with frequent openings causing traffic delays. Delays ended in 1997 with the present fixed-span bridge opening.

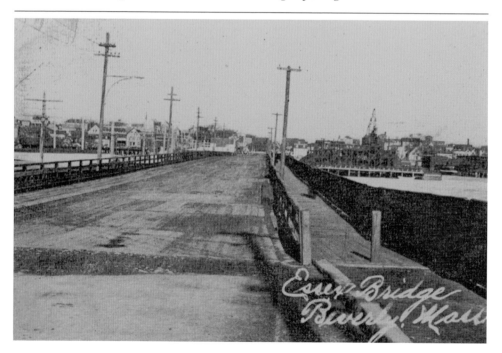

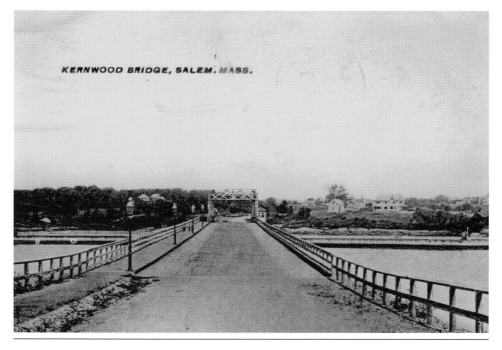

KERNWOOD BRIDGE, SALEM, MASS.

Kernwood Bridge, which connects North Salem to Beverly, was built in 1907. This bridge is just down the road from the Kernwood Country Club. The golf course opened in 1914. This highway and bridge have been updated over the years with the replacement of the wooden rails in favor of steel. The bridge is the last drawbridge in Salem and still is opened frequently for boats using the Danvers River. It is listed on the Massachusetts Historic Bridge Inventory.

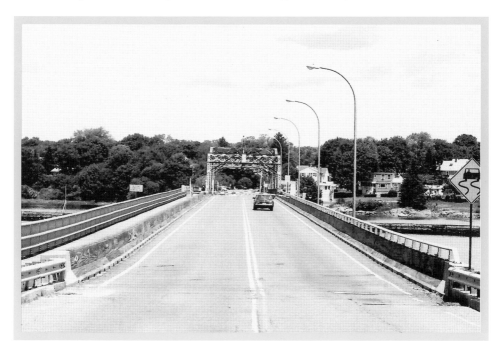

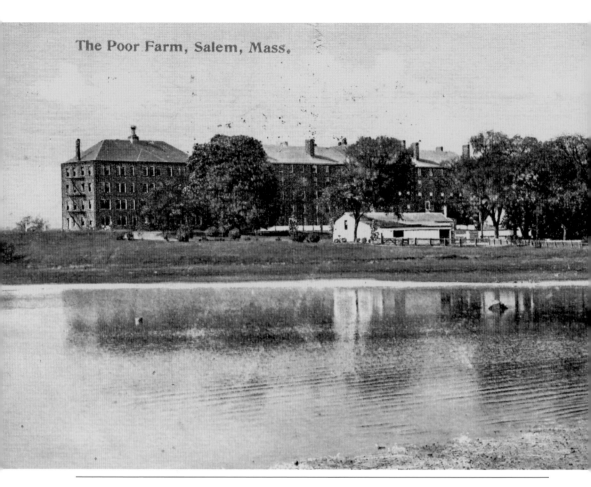

The Poor Farm, Salem, Mass.

On November 30, 1816, the almshouse, or poor farm, was opened on Salem Neck. Attached was a 70-acre farm. Designed by the noted architect Charles Bulfinch, the buildings stood for many years. All but one of the buildings were razed by 1954 with the one being used as a chronic disease hospital until 1976, when Shaughnessy Hospital opened. After falling into disrepair, the building was torn down in the early 1980s and replaced by a condominium development.

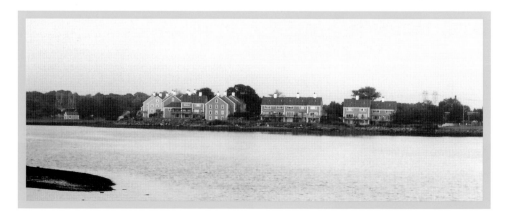

The Naumkeag Steam Cotton Company, incorporated in 1839, was a mainstay of manufacturing in Salem and a major employer. Pequot sheets and pillowcases were made here. The mill was destroyed in the fire of 1914 then rebuilt. It closed in 1953 when manufacturing stopped.

The mill buildings were converted to industrial buildings and warehousing in 1958. Pickering Wharf renovations spurred conversion to office space in 1980. Pictured in the foreground is the Pickering Wharf area of shops, restaurants, condominiums, and a marina.

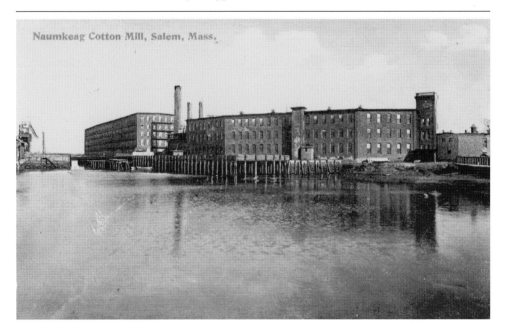

Naumkeag Cotton Mill, Salem, Mass.

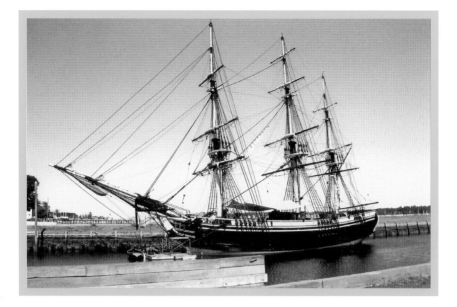

The derelict barge *Richard* is seen moored at Derby Wharf in the early 20th century. This is poignant testimony to Salem's fall from 18th- and 19th-century trading preeminence, when the port of Salem, with some 40 wharves, processed goods from around the world. The view of the tall ship *Friendship* shows a re-creation of a 1797 Salem ship used in the East India trade. It is a popular tourist attraction that conjures up Salem's maritime history.

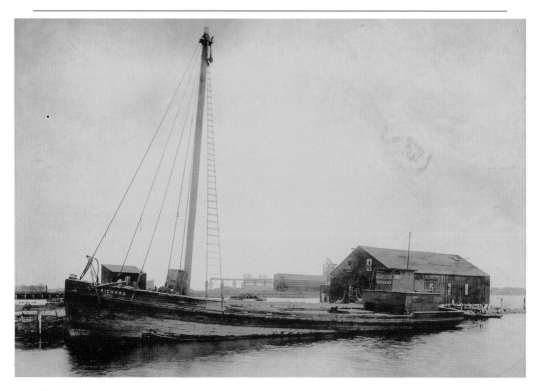

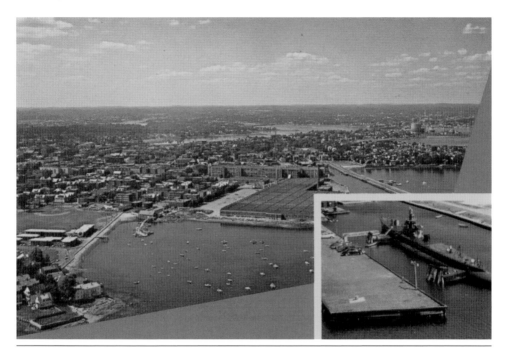

This bird's-eye view of Salem Harbor is from the 1950s. The mill complex in the foreground had closed. Derby Wharf, which extends into Salem Harbor a half mile, had a World War II submarine, the USS *Shad*, docked alongside when there was a naval reserve station here. The current scene shows that much development has occurred across Salem with many larger buildings expanding and changing the city's profile. Now docked at Derby Wharf is the replica tall ship *Friendship*.

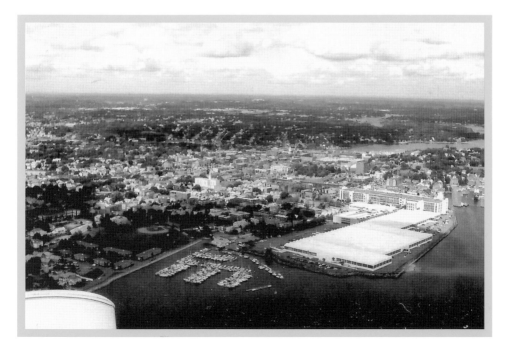

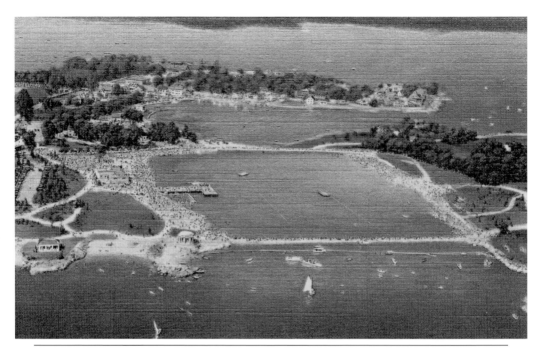

This aerial view shows Smith Pool in Cat Cove, the largest open-air pool on the Atlantic Ocean and a popular swimming and recreation area in the early 20th century. The Cat Cove tidal pool and adjacent 16-acre site is now the Cat Cove Marine Laboratory operated by Salem State College and is home to the Northeastern Massachusetts Aquaculture Center. This is a research and educational site that offers a number of programs on ocean management and ecology.

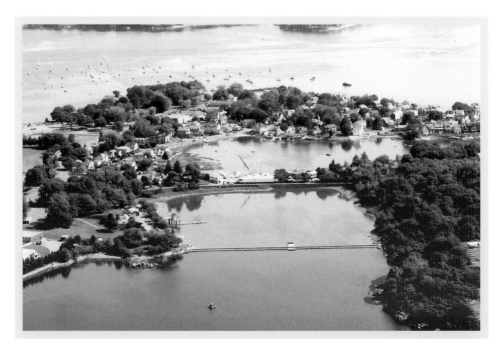

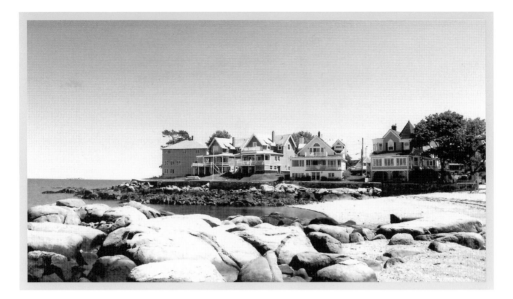

Juniper Point is a short walk from Salem Willows. With its commanding placement overlooking Beverly and Salem Harbors, it was one of three fort sites during the Revolution and the War of 1812. These forts offered protection to the privateers while they were fleeing British navy ships. While the other forts, Pickering and Lee, remain on Winter Island, this area was developed early and was home to three hotels, then summer cottages, and now year-round homes.

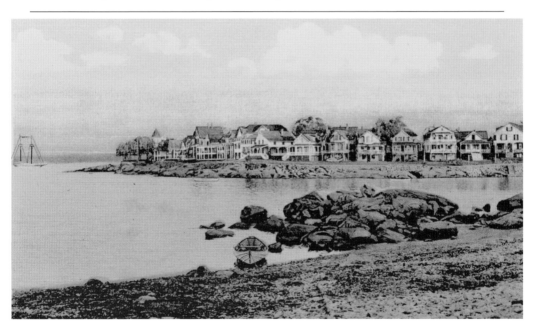

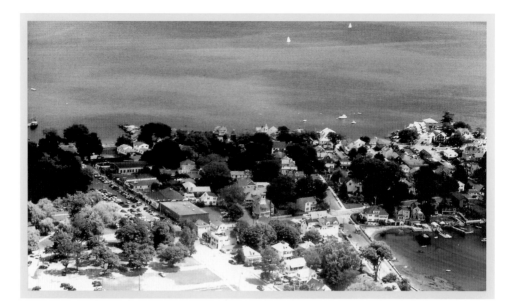

Juniper Point, which lies adjacent to Salem Willows, juts out into Beverly Harbor. This postcard was taken in the early part of the 20th century. Salem Willows, with its restaurants and dance pavilions, can be seen on the left. Juniper Point at this time was mainly summer homes. The current view shows the Salem Willows buildings that now house arcades, rides, and a few restaurants. Juniper Point is now more populous with year-round homes.

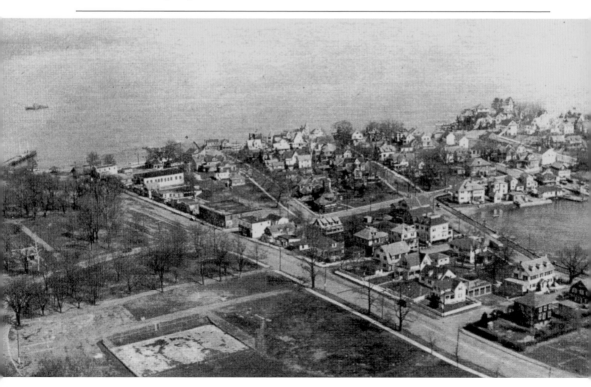

ALONG THE COAST

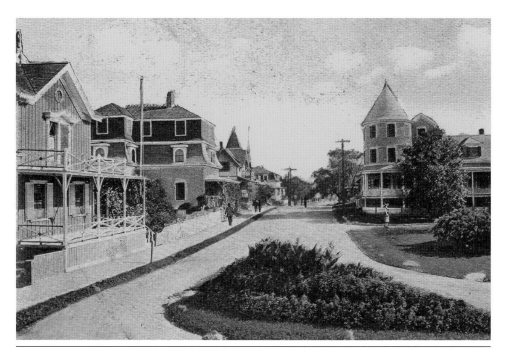

This view of Beach Street in the Salem Willows section runs from the Salem Willows Park along the coast to Juniper Point, the farthest land point of Salem. Salem also encompasses Baker and Misery Islands in the harbor. These houses built in the late 1800s and early 1900s have not changed externally while being weatherized to withstand harsh storms and cold. Also part of the Salem Willows section is Winter Island, with its one road that leads to the park area.

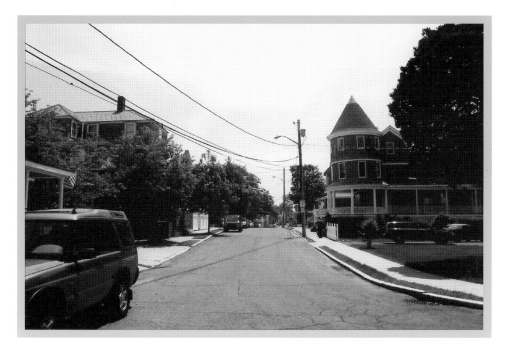

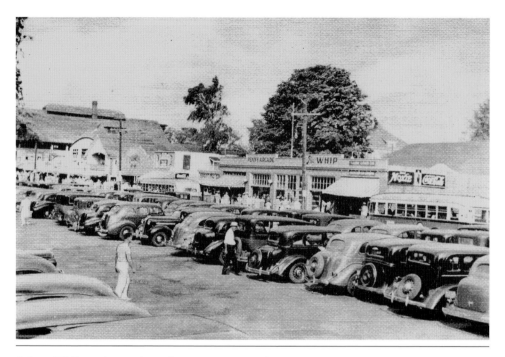

Salem Willows has a long history as an amusement center for Salem and the North Shore. For over 100 years, people have flocked to this park that juts out from Salem Neck into the harbor, offering cool breezes during hot summers. Over the years, dance pavilions have given way to arcades. While the merry-go-round is still a favorite, the original hand-carved animals were sold to the New York Macy's Department Store for its Christmas displays in 1945.

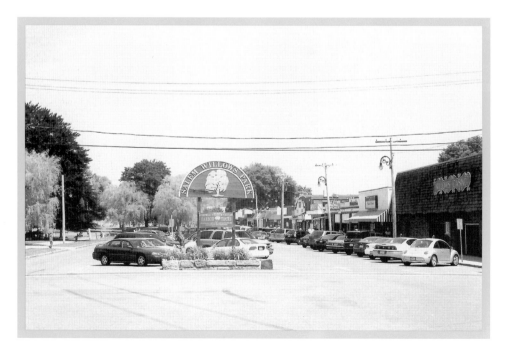

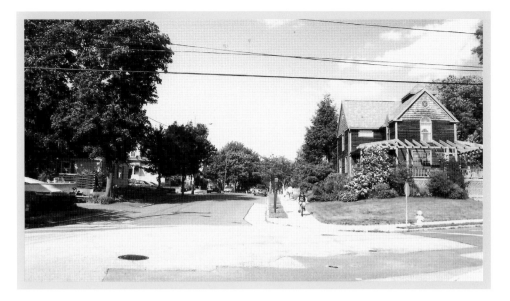

Just behind the Salem Willows Park, at the end of Salem Neck, a summer community grew up at the start of the 20th century. With the cool breezes, the park and ocean were an ideal place for summer cottages and hotels to be built. Over the years, the hotels have gone while the cottages have been converted to year-round dwellings. This small community within the city still maintains its unique identity as an intimate seaside neighborhood.

Salem Willows, Mass, Columbus Ave.

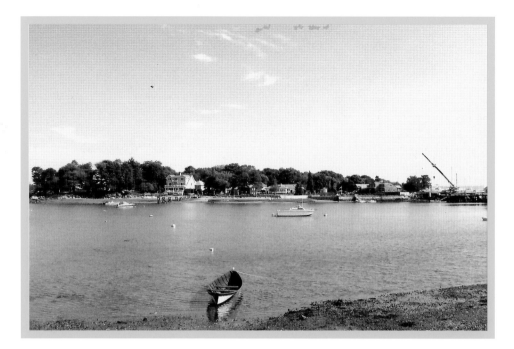

Across Juniper Cove from Salem Willows is an area called Winter Island that commands a view of Salem Harbor. It was here that forts were set up and manned during the Revolutionary War, the War of 1812, and the Civil War. The remnants of Forts Pickering and Lee are still visible. For years, the federal government used this area for a Coast Guard base. No longer a Coast Guard station, this area has become popular for camping and boating.

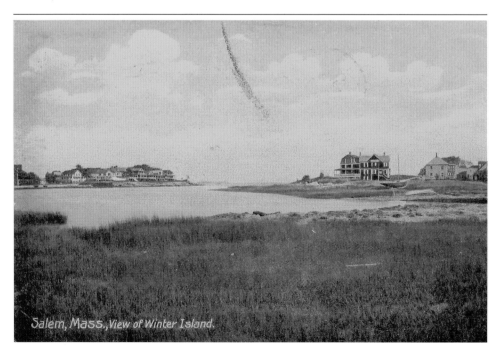

Salem, Mass., View of Winter Island.

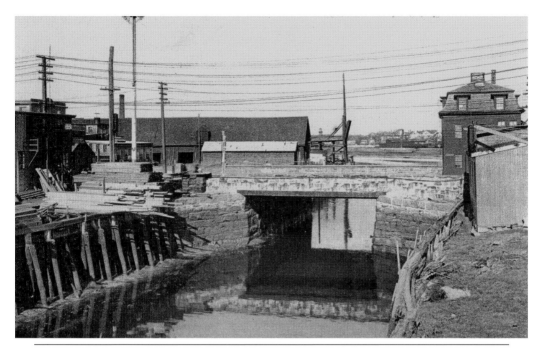

The Old North Bridge was the site of Col. Alexander Leslie's retreat, the first armed resistance of the American Revolution. Leslie, attempting to seize weapons from colonists, was met by an open drawbridge and armed colonists. In trying to stop colonists from destroying boats they might use, one colonist was cut, drawing first blood. Negotiations by the Reverend Thomas Barnard led to the British retreat only to have war begin 51 days later at Lexington and Concord. Now there is an overpass.

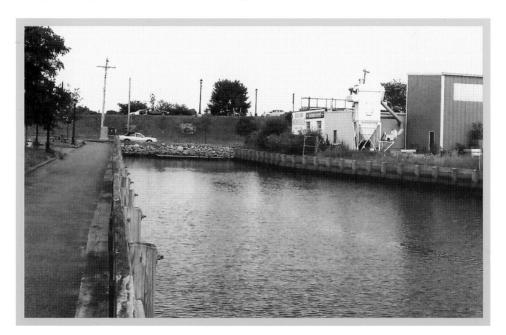

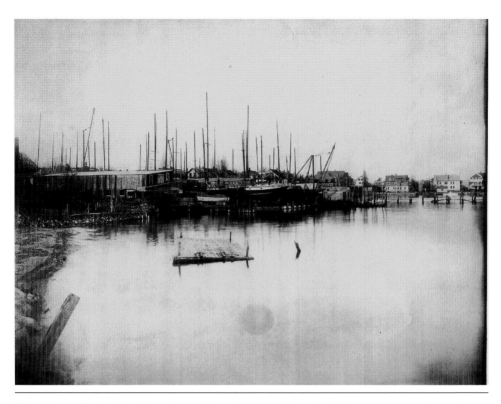

The Dion Yacht Yard is pictured as it looked in 1933. This was a leading yacht yard on the North Shore for many years. Fred Dion built, rebuilt, and repaired hundreds of wooden yachts and was sought out for his skill and expertise. Dion reminisced of his days smuggling during Prohibition when rumrunners brought in illegal alcohol from the sea. Known as a character, Dion was one of the last "iron men on wooden ships."

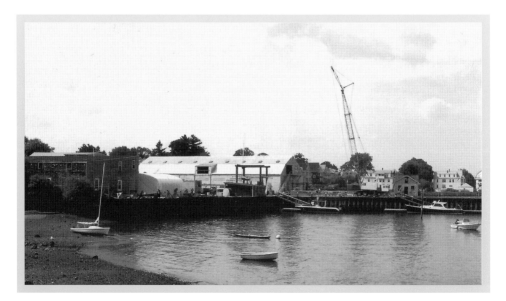

Pioneer Village is an 11-acre re-creation of Salem as it was in 1630. The village is located in Forest River Park in South Salem. This first living-history museum was built by the City of Salem in 1930 as part of the Massachusetts tercentenary celebration. Stressing authenticity in all things, the village has been a popular tourist and educational destination over the years but has suffered through difficult economic times when there was little support for the village.

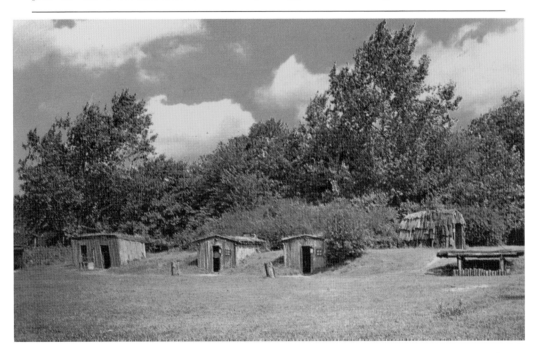

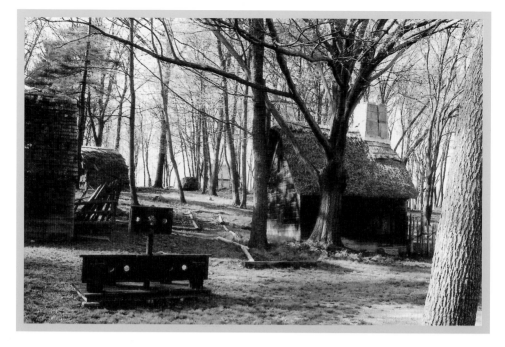

With hard economic times, fires, and vandalism, Pioneer Village fell into disrepair and was to be razed in 1985 when it was rescued by concerned historians. With the help of volunteers and grants, it was restored and reopened briefly in the early 1990s, then once again fell into disrepair. Currently it is being restored and will be managed by the Gordon College Institute for Public History and has recently been used as a movie site.

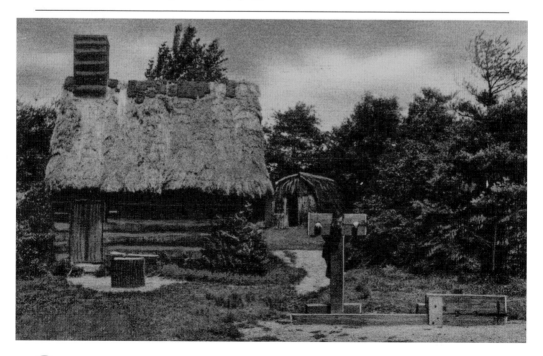

CHAPTER 5

STREETSCAPES

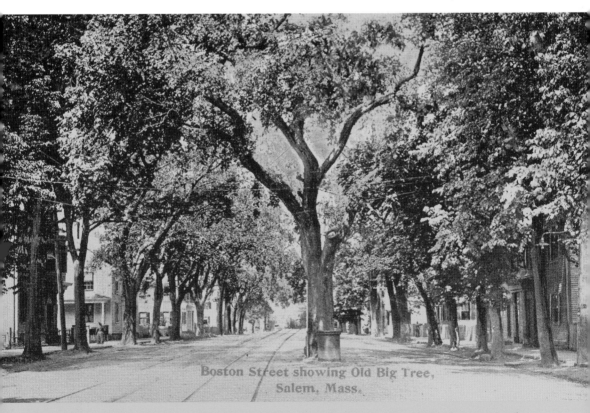

Boston Street showing Old Big Tree,
Salem, Mass.

Boston Street was a tree-lined avenue marked by a big tree leading toward Peabody. Blubber Hollow, the area around Boston and Bridge Streets, is close to where the devastating fire of 1914 began. Nearby to the old tree at 94 Boston Street, built in 1790, was the Frye Tavern, one of the last Colonial taverns in Salem.

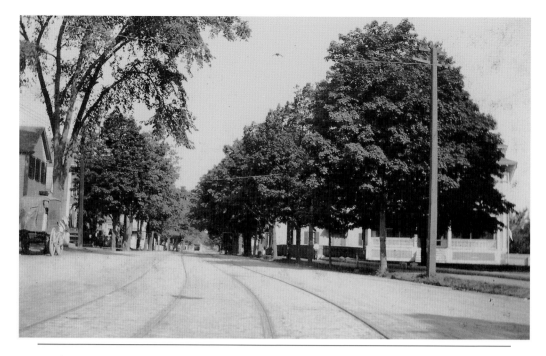

In this view of North Street, the rails for the streetcars to Peabody and Danvers can clearly been seen. The rural nature of the area gave way in the 1800s as Salem expanded its housing away from the center of the city. Seen here is an interesting mix of Federal, Greek Revival, Queen Anne, and Italianate architectural styles reflecting the periods of Salem's growth. The houses pictured were built in the later half of the 19th century.

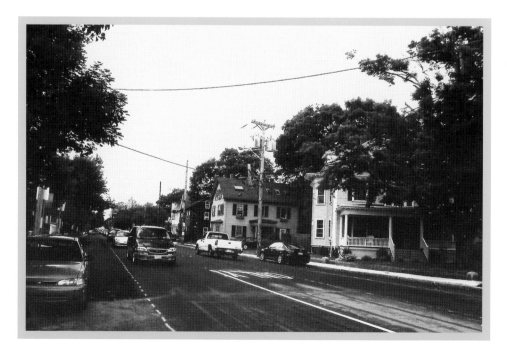

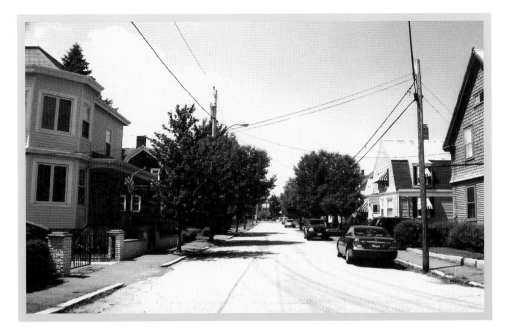

In 1897, George Woodbury, a descendant of John Woodbury, who came to Salem in 1626, had an idea that Salem's expansion from downtown would spread to the Northfields, a farming area that separated Salem from Peabody. He bought land to develop as house lots on Fairmont Street, pictured here early in the second decade of the 20th century, as well as Woodside Street. With its proximity to Harmony Grove Cemetery and closeness to Salem Center, his investment proved to be an excellent one.

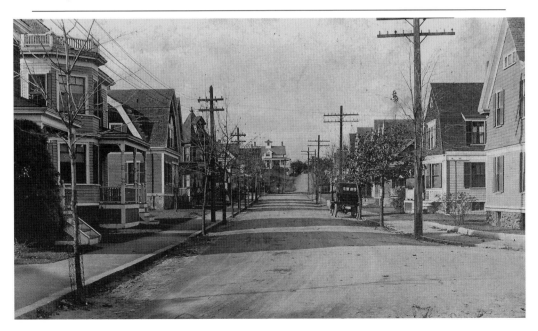

Dearborn Street in North Salem was originally part of the Northfields. These houses were mostly built in the 1800s. This interesting street has a number of different architectural styles representing various periods of the 19th century. A notable house, second on the right, is No. 28 where Nathaniel Hawthorne resided from 1828 to 1832 in the Manning cottage, built for his mother by her brother. When Hawthorne lived here, the house was across the street.

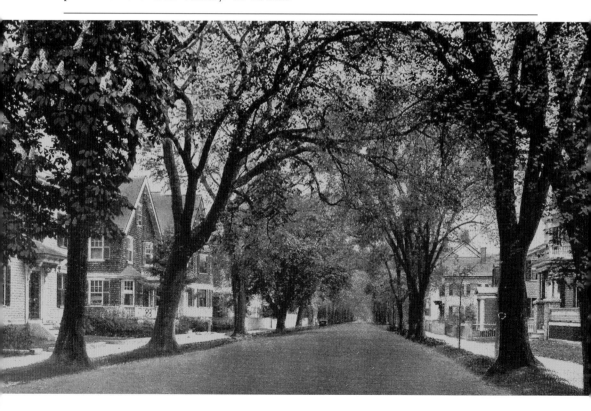

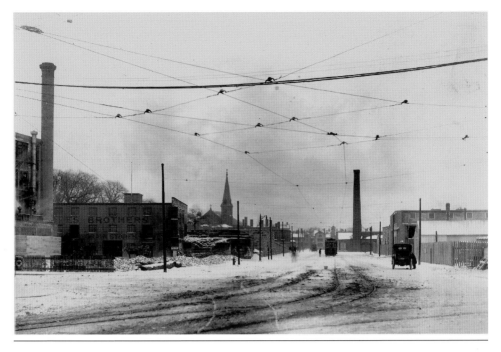

This vintage view of New Derby Street shows the back of Salem Laundry on the left along with the Ropes Brothers Grain Stores. In the distance is Immaculate Conception Church on Hawthorne Boulevard. The brick wall on the left is the retaining wall for the Charter Street Cemetery. In the contemporary image, one can see how developed this area has become. The old laundry is now luxury condominiums. There are also shops on the left and a pirate museum, as well as witchcraft attractions.

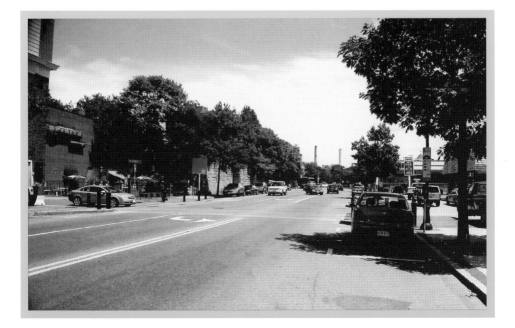

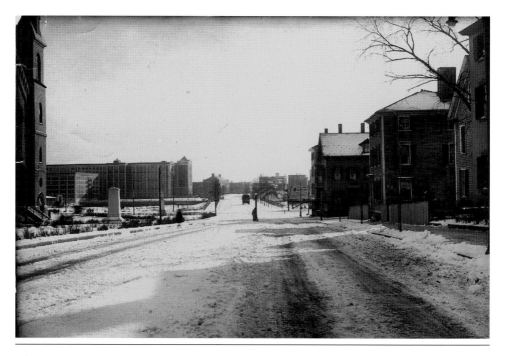

This view of Hawthorne Boulevard documents some of the design changes that happened after the "Great Salem Fire of 1914." The Congress Street bridge leading toward the Naumkeag Mill originally was one block over on Union Street. After the fire and rebuilding of the mill, the bridge only entered the mill complex, so it was moved to Congress Street, which bordered the mill area and leads into the Stage Point neighborhood. The current bridge was rebuilt in 1995.

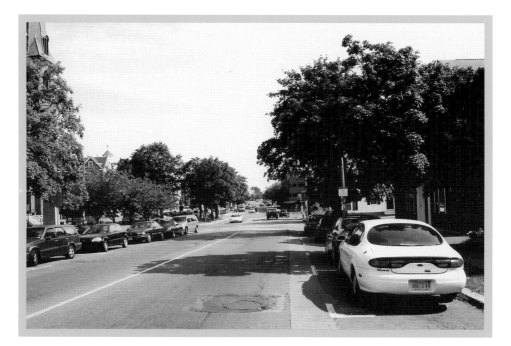

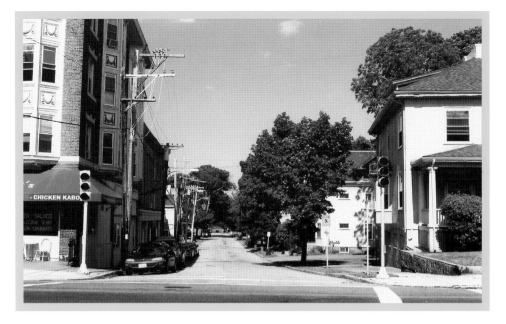

Leach Street from the corner of Lafayette Street is shown here prior to the Salem fire of 1914 when this area was destroyed. As the fire sought to spread farther down Lafayette Street after devastating an area one and a half miles long and one mile wide, it was halted in this section by dynamiting buildings on Holly Street opposite Leach Street, making a firebreak. Leach Street was in the burn zone but was quickly rebuilt.

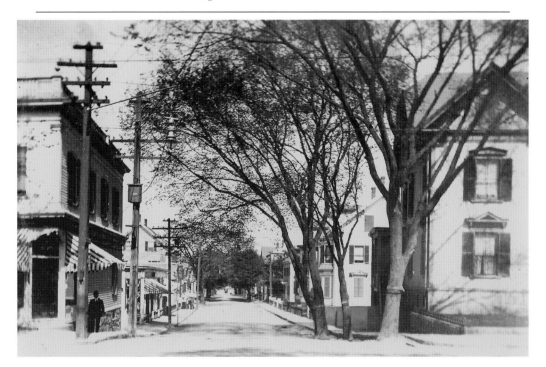

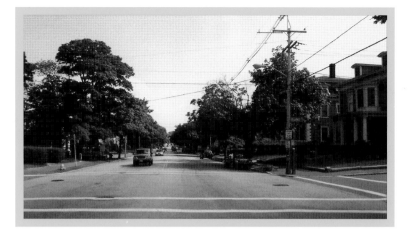

Lafayette Street was home to a number of stately homes and mansions built by business leaders and manufacturers in the mid- to late 1800s. Many of the buildings were lost during the Salem fire of 1914. This view is of the section closer to the Salem Normal School, which was spared from the fire. Many of these houses still stand after having been converted to apartments and office space by the housing demands the growth of Salem brought about.

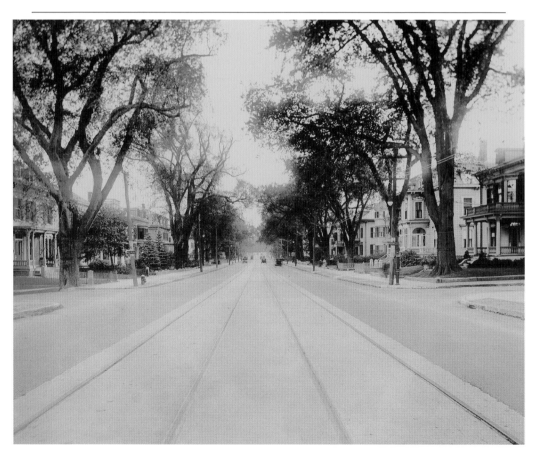

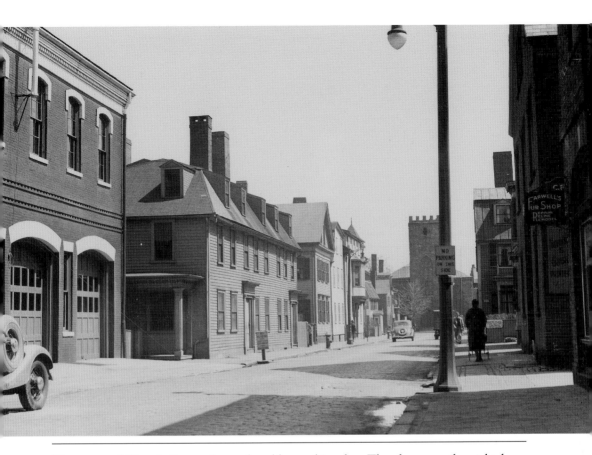

This view of Church Street shows the old Central Fire Station as well as houses and shops lining the street. The houses beyond the fire station gave way first to a gas station owned by Almy, Bigelow and Washburn, which was across the street, then to a parking lot. The shops on the right have been supplanted by condominiums and municipal offices. Not seen but noteworthy is the Lyceum Restaurant where Bridget Bishop, a victim of the witchcraft hysteria, had her home.

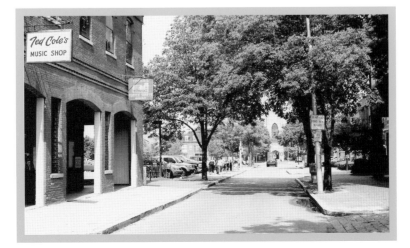

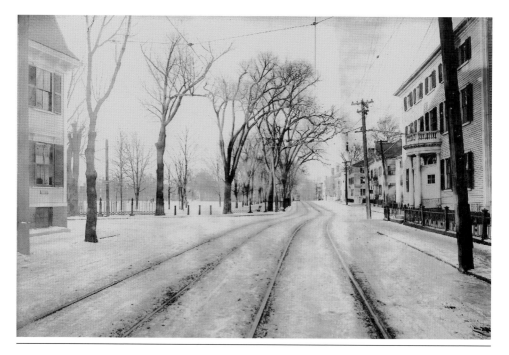

The snowy view of Washington Square East shows a corner of Salem Common laid out as a park in 1802. Shortly thereafter, stately houses bordered Washington Square. On the right at No. 74 is the Crowinshield home built in 1804 by Samuel McIntire, noted wood-carver and architect. In this house lived Capt. James Devereux, who was the first American ship captain to trade with Japan. Now the streetcar rails are gone, and there is a new playground on the common.

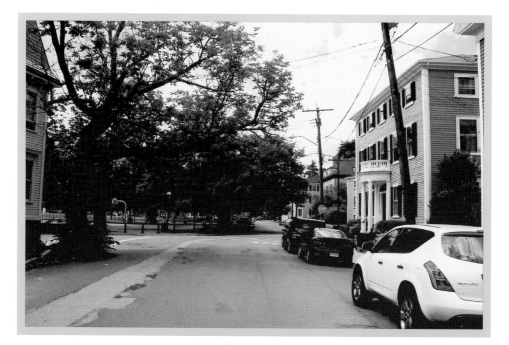

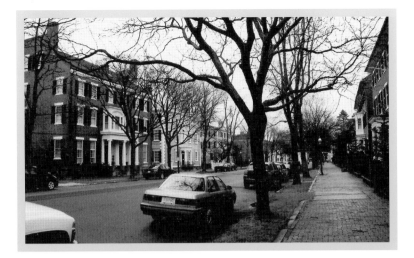

P. D. James, the noted English mystery novelist, called Chestnut Street "one of the most beautiful streets in America." A short distance from downtown and the many wharves that are all gone now, wealthy merchants and ship captains had their mansions built by the best architects available. These elegant homes represent some of the finest examples of Federal and Colonial architecture anywhere in America and are a national treasure. At various times during the year, some are open to the public.

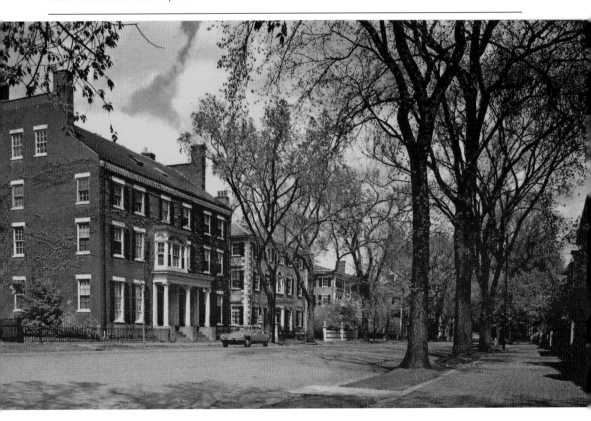

In this view looking up Chestnut Street is the Lee-Benson house at No. 14. This Greek Revival house was built in 1834 for John C. Lee, a banker. It was home to the famous impressionist painter Frank Benson from 1925 to 1951. At No. 10 is the Robinson-Little house. This was built for Nathan Robinson, a merchant. Phillip Little, another well-known painter, later lived there and painted with Benson. The Old South Church, designed by Samuel McIntire, is seen before it was destroyed by fire in 1903.

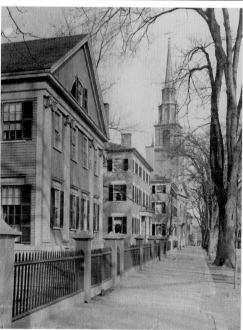

INDUSTRIAL SALEM

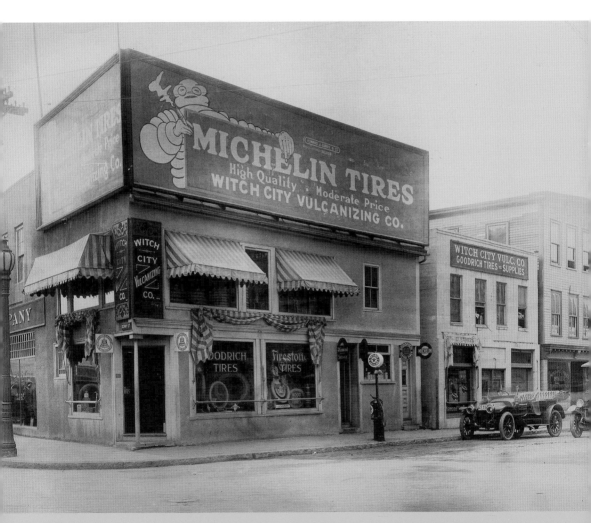

The Witch City Vulcanizing Company, shown here in the 1920s, was located where the main fire station now is on the corner of Lafayette and Derby Streets. Note the Texaco pump on the sidewalk. In 1915, Derby Street was extended to Washington Street by removing the Fairfield Dock and filling and covering the South River to make New Derby Street.

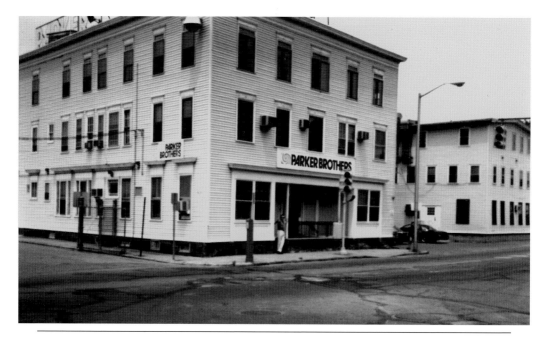

In 1883, 16-year-old George Parker started his game company, selling his game Banking. His brothers joined him to form the Parker Brothers Company. For the next 85 years, Parker Brothers sold popular games including Monopoly, Clue, Sorry, and Risk. This 1994 photograph shows the original Parker Brothers building, built in the 1860s. Due to corporate mergers, it was torn down in 1996. An apartment complex is now here. (Historic photograph by Tony Lemone, courtesy of Phil Orbanes.)

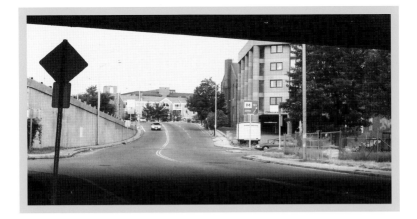

The vintage view shows Bridge Street as it crosses the top of Washington Street not far from the North River. This part of Bridge Street was home to a number of businesses such as Amour and Company meatpacking, Naumkeag Paper Company, and Atkins and Brown building materials. This was a semi-industrial area. One can now see that all the buildings are gone and the area has been redesigned to accommodate an overpass ramp for the North River.

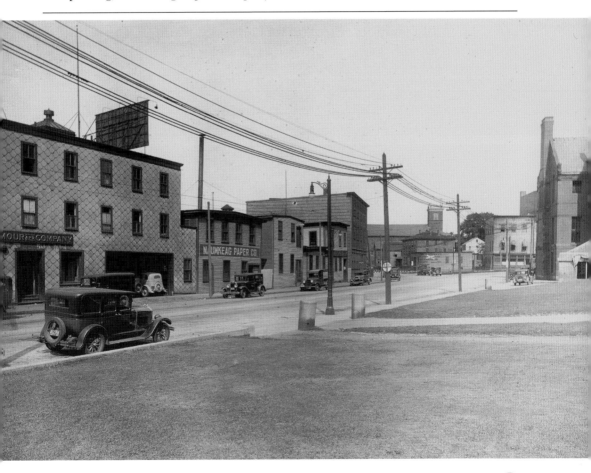

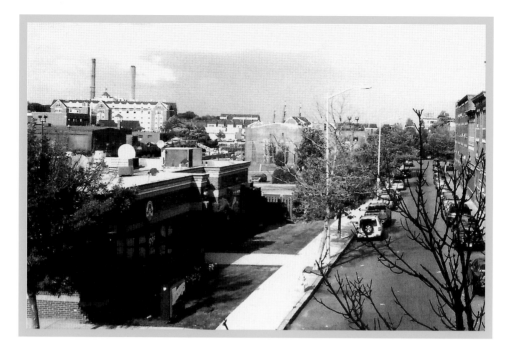

Peabody Street at the beginning of the 20th century was the site of the Salem Electric Light Company, which opened in 1889. Salem had a history of inventors interested in electricity. In 1771, lectures on electricity were offered at Col. David Mason's home by the North Bridge. In 1859, Prof. Moses Farmer was first to illuminate a house, his own, with electric light. In the contemporary photograph is a substation, as well as the current power plant's smokestacks in the distance.

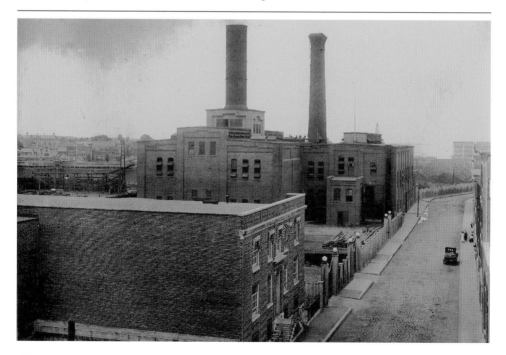

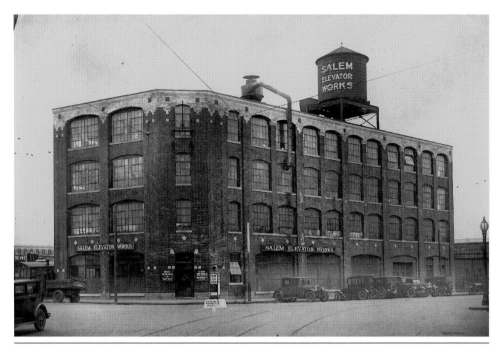

This building at 76–80 Lafayette Street was constructed in 1915 to house the successful Salem Elevator Works previously at 244–246 Canal Street. At the time of this photograph, it also housed the Dinsmoore Manufacturing Company, Tillinghast Supply and Machine Company, and Duke Machine Company, all of which made textile sewing machines and supplies. Presumably they were suppliers to the huge Naumkeag Mill on Congress Street. This building was part of the rebuilding of Salem after the devastating fire of 1914.

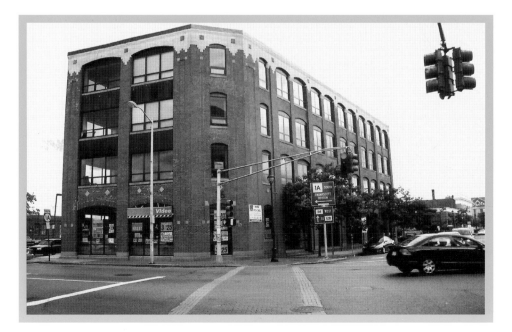

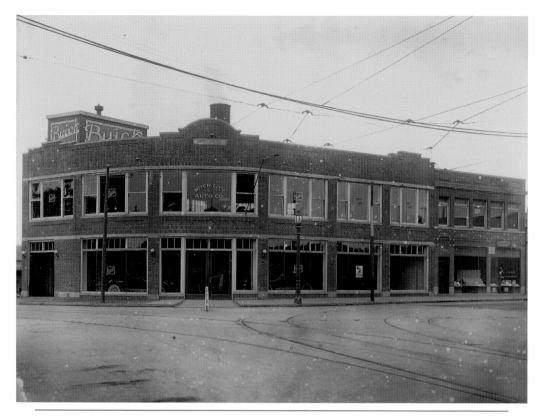

The Goldberg Building on the corner of Lafayette Street and New Derby Street housed a Buick dealership. This photograph shows 1920s-model Buicks in both the showroom on the ground floor as well as upstairs. At the end of this block, there were two businesses: Gaudette Druggist and a pool parlor on the second floor. The current occupant is Beverly Cooperative Bank and Keller Williams Reality. The name has now been removed from the building.

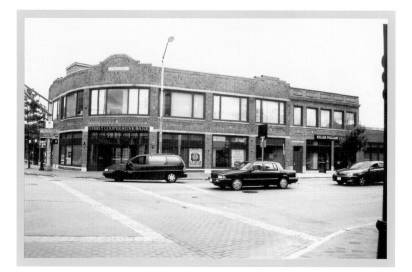

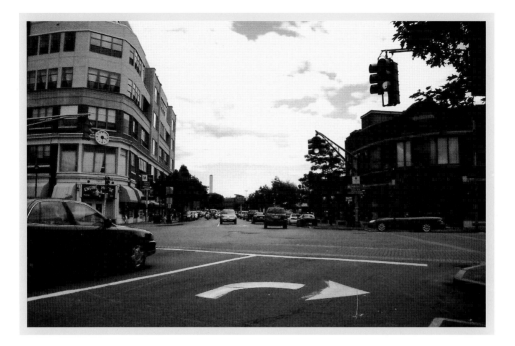

This is another view of the Goldberg Building and the intersection of Derby Street and Lafayette Street as it looked in the 1920s. On the left the Salem Vulcanizing Company, and a partly obscured Ropes Brothers company can be seen as well. Before Derby Street was filled in and extended in 1915, this area contained the Fairfield Dock on the South River and the South Bridge. At that time, ships navigated up to what are now New Derby and Washington Streets.

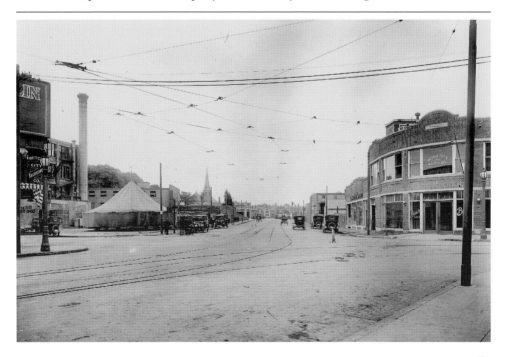

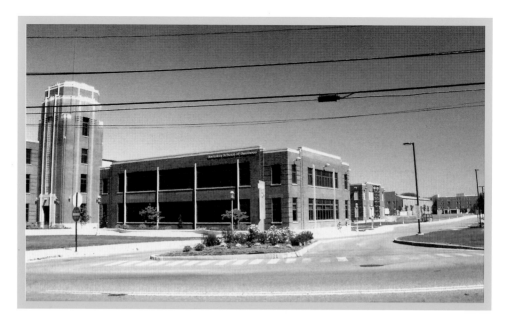

For many years, the Hygrade Sylvania and later Sylvania Electric Inc. dominated this part of Loring Avenue. Built in 1936, the structure reflects the art deco style. This site encompassed about 32 acres and was used to manufacture radio tubes then incandescent lamps in 1946. Almost 700 people were employed here in the 1970s and 1980s. After merging with Osram, a German company, this plant was closed in 1989–1990. This site is now the Salem State College Bertolon School of Business.

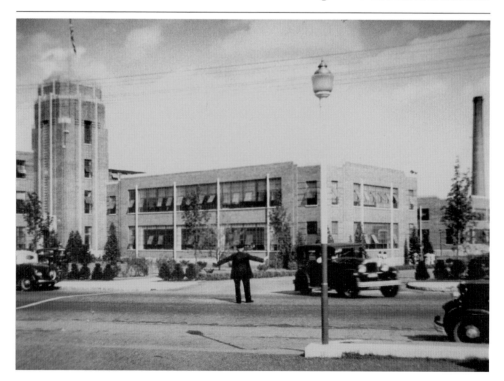

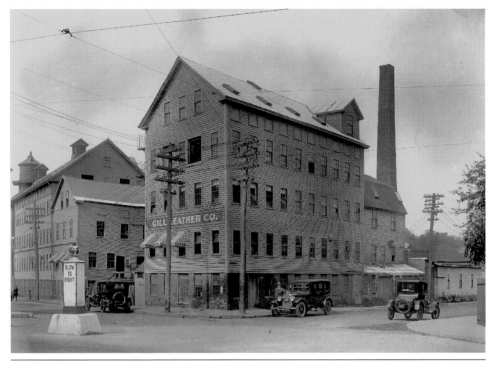

The large Gill Leather Company factory, on the corner of Bridge and Grove Streets, was one of several dozen tanneries in the city. This area along the banks of the North River, which ran behind the plant, was an ideal factory site in the days before environmental protection. The area was industrialized by factories and tanneries. The North River, which was once large enough to launch merchant ships, gradually became a polluted canal. A large storage company is now on the site.

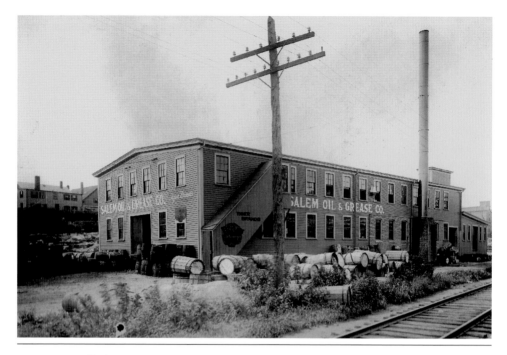

From a small shop in 1909, the Salem Oil and Grease Company grew into an international provider of oils and grease for use in the tanning industry. It is these oils that determine the colors of leather. This company closed in 2003 when acquired by Stahl International, a Netherlands-based company. On this site was a gristmill in 1712. In the late 1700s, a shipyard that built and launched some 40 ships for the East India trade was nearby.

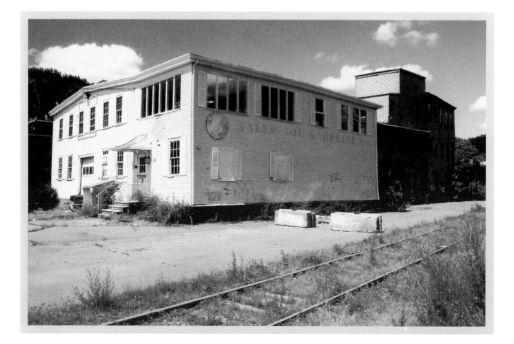

Grove Street was known as a highway in 1712 when the land was given to Capt. John Trask for the building of a gristmill. A condition of the grant was that he build and maintain a highway and bridge over the North River. This area became known as Blubber Hollow when factories processing whale blubber for candles were built in the 1850s. Shown here is the Salem Oil and Grease Company that served the tannery industry for many years.

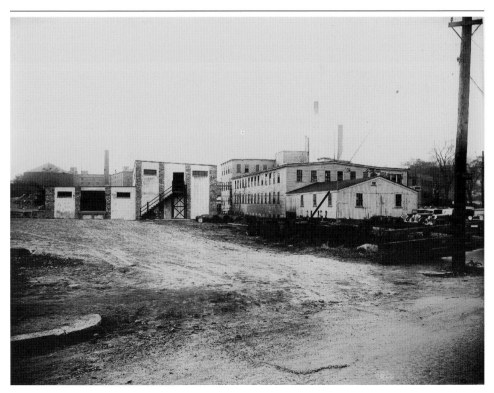

ACROSS AMERICA, PEOPLE ARE DISCOVERING SOMETHING WONDERFUL. *THEIR HERITAGE.*

Arcadia Publishing is the leading local history publisher in the United States. With more than 3,000 titles in print and hundreds of new titles released every year, Arcadia has extensive specialized experience chronicling the history of communities and celebrating America's hidden stories, bringing to life the people, places, and events from the past. To discover the history of other communities across the nation, please visit:

www.arcadiapublishing.com

Customized search tools allow you to find regional history books about the town where you grew up, the cities where your friends and family live, the town where your parents met, or even that retirement spot you've been dreaming about.